SEARCH FOR MY SON-
A SOLDIER'S STORY

By

Geneva Johnston Hudson

ISBN: 0-7596-8228-3

This book is printed on acid free paper.

Printed and bound in the United States of America.

1stBooks - rev. 04/12/02

Also by Geneva Johnston Hudson

Oklahoma: The World Around us. The Macmillan Publishing Company, 1990.

Barefoot In An Oklahoma Sticker Patch.
Gem Publishing, 1996.

Shaping Oklahoma: A Map Study.
Gem Publishing, 1999.

For those who serve in
Signal Corps
United States Army Military Intelligence
and
The mothers who love them.

JEWELS OF WISDOM

Some people say that time is just a measure of distance through space. Some people say that time is a river by which the flow of events throughout the universe moves in one continuous unidirectional stream. Some people say that time is not linear at all with past, present, and future all existing simultaneously, as if in some giant pool and we only experience the linear aspects of time because we only interact with it at one point as opposed to being diffused throughout the pool.

———

The rewards of memory are not only received for overcoming the obstacles of life, sometimes they are gained for simply managing the mundane.

———

There comes a day in your life when you realize you're just not going to get there, wherever that "there" might be. It doesn't mean you stop dreaming, it just means you accept working on the probables instead of wishing for the possibles. It just means that you can find satisfaction in something less than the "perfect life." It just means you stop being a child. As important as a birthday, the day of acceptance of life as it comes is the first day mortality is comprehended.

———

Something has to affect us deeply to change our perspective on the way we interact with the events that surround us.

—MSGT Barry Kent Hudson

ACKNOWLEDGMENTS

When a writer reaches the point of coming to terms with the necessary courtesy of acknowledging those who readily responded to the request for help, all talent seems to desert you and your pen runs dry.

My request for information, even though I often didn't know for what I was asking, was responded to with kindness and an overwhelming desire to be of service. My acknowledgment is surely to omit some who took time to search for answers for me. I want to especially recognize the clerks and secretaries of the "brass" who most surely handled a special request as a part of a days work.

Department of Army, United States Intelligence and Security Command, Shirley K. Statzman, Acting Chief of Public Affairs, who sent me a copy of *Military Intelligence: A History of United States Intelligence and Security Command,* and a Military Intelligence photographic CD. She included a personal note, "Good luck with your labor of love."

James A. Chambers, Deputy Garrison Commander, United States Army Intelligence Center and Fort Huachuca, whose personal note read, "Hope your holiday season is warm and bright in spite of all you've been through." The courtesy and attention from this office showed respect and concern. I am deeply touched and grateful.

Steve Echard, Chief Personnel Processing Services & Student Processing Division, Fort Huachuca.

Department of the Army, United States Army Enlisted Records and Evaluation Center, Indianapolis, Indiana.

Earnest Istook, Fifth District Congressman, Oklahoma, and especially Atthalee Ripley who expeditiously took care of my request.

Department of the Army: The Institute of Heraldry, Fred N. Eichorn, Director. Authorization to use Military Intelligence Regimental Insignia.

Finally, friends and family who helped me get through those difficult days, and continue to stand ready to wipe away my tears.

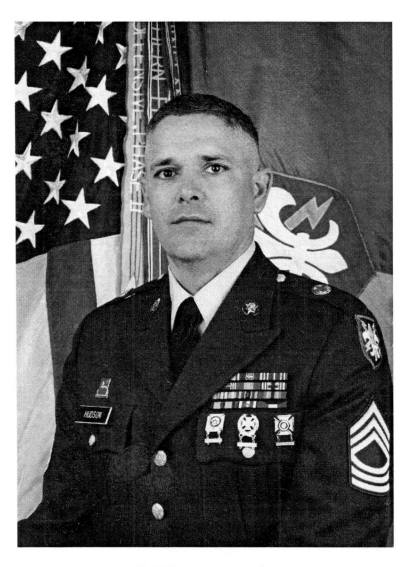

MSGT Barry Kent Hudson
1955-2000

ALWAYS OUT FRONT

PREFACE

My purpose in gathering this material and sharing it with the reader is two-fold. First it is in search of my son, the soldier, who died on January 27, 2000 just a few days short of his twenty year retirement as a Military Intelligence soldier.

Barry Kent Hudson was born in Guymon, Oklahoma on March 10, 1955. He was the only child of Grant and Geneva Hudson. He grew to manhood in Edmond, Oklahoma, having moved there with his parents in 1964. After graduating from Edmond High School, he received a BA degree from The University of Oklahoma in 1977. An honor student, his degree represented an education more than a career. His graduation came at a time when the job market was beginning to focus on specific technological career training. Barry had difficult finding that career job without further training. When approached by U. S. Army recruiters, who wanted to take advantage of his fifteen hours of college Russian, he signed a contract that led to a Military Intelligence career. From that day forward for nearly twenty years my son was a soldier — a part of his life he never fully shared with me.

When Barry came home on leave, he wanted to be at home, enjoy his room, sleep in his bed, eat his favorite foods, laugh and visit with friends and wave at the neighbors. He put his soldier-life aside at these times. Consequently, he was my son, not a soldier. During his last visit in September 1999, just four months before his death, he was excited about his retirement in February 2000. His excitement was electrifying. He had job interviews and offers, his hopes were high. He was looking forward to a new life. FEBRUARY 2000 was highlighted during that visit. He was buried on February 1, 2000.

My second purpose is to share a little of what I came to know of my son, the soldier, in those last few hours of his life. I was privy to an experience of which every American should be proud. I was told by a nurse in Darnall Army Community Hospital, Ft. Hood, Texas, that the MI soldiers were special. I came to believe that the word "special" was inadequate. During the last thirty-six hours, as my son faced his last battle alone, his unit stood by in numbers as he met the challenge. The Unit did not just send someone to keep the vigil, they came in numbers, the Commander, Captain, 1st Sergeant, Chaplain, among others who lined the halls to add their strength to their comrade. They were my comfort, and when the word was passed that the support system was being turned off, they stood at attention as the line went flat.

Filled with stories, like all hospital and ER waiting rooms, tear stained feverish children nestled against the breasts of worried mothers, young women in various stages of rounding stomachs chatted about due dates, morning sickness and previous labor, a young father trying to hide his anxiety put his strong arms around his children as their mother followed a nurse to an examining room, a lad of ten proudly examined a quickly drying cast, others sat reading, restlessly shifting about in the uncomfortable chairs, ever on the alert for their name to be called, announcing it is their turn to see a doctor.

I sat among them that late afternoon in January 2000. I had come to Fort Hood less than six hours earlier from Edmond, Oklahoma. Fatigue from the trip was heavy upon my seventy-nine year old body. With eyes fixed in a stare on the heavy double doors behind which ER nurses were preparing my son for admittance to the intensive care unit, I tried to find hope. The words Barry had not said raced through my mind, "Mom, the tests are in, the prognosis - keep him comfortable - I'm sorry."

Barry had spent most of September 1999 at home with me, having just returned from his last tour in Germany. His health was not a concern, except he did complain of back pain, now and then, jokingly, saying, "This might get me a medical retirement, then I'll not have to buy car tags anymore." Just before returning to duty at Ft. Hood, he mentioned he had gained too much weight and started cutting back on his food. "The Army has 'a thing' about overweight," he said, "and I don't want fat to get me dismissed before my twenty years are in."

His Thanksgiving phone call home reported he wasn't feeling too good and had been going to the doctor about his back. At Christmas time he said he was undergoing some test. "Seems I have cancer somewhere," he said, "but they're going to find it, zap it and I'll be okay. Don't worry." Positive upbeat. "Don't go to the internet and read a lot of stuff about cancer and worry. I'll let you know what's happening," he cautioned. Nevertheless, I kept my eyes and ears open for positive information on television and the internet. I especially listened to those who reported that the cure for cancer had reached an all time high, and the attitude of the patient was very important. Barry's attitude was great, so I relaxed with that information. A large percentage of cancer can be cured if detected soon enough, I heard, and of course there were warning signs to help with that early detection. Another plus, for me to tie my hopes to.

More test followed at Fort Sam Houston Cancer Clinic in San Antonio, Texas and Walter Reed in Washington, D. C. The results of these tests were in on January 20, 2000. "Mom, it isn't good. It's called carcinoma unknown primary (CUP). They're going to start chemo and in six weeks test again to determine one of three things, 1) cancer arrested, 2) making progress, continue treatment, 3) keep him comfortable," he reported. "We won't get the first one," he said hesitantly, "But we can hope for the second one. Cause if it is #3 they will just put me in the hospital and hook me up to a morphine drip." He didn't

tell me, but I firmly believe he knew #3 was already his fate. I suspect this because of the unfolding of events that followed. He made plans with his three best friends for a weekend visit, between these planned visits he asked me to come. He tried to prepare me for his extreme loss of weight and his weakened condition, but I cannot describe how I felt when I walked into his apartment. The healthy young man, I had seen just four months earlier, was hollow-eyed and weighed little more than 120 pounds. Choking back my feelings, I immediately said, "Barry, you need to be in the hospital."

"I know," he answered. "But let me tell you when I'm ready." Trying to put reason to his hesitation to go to the hospital, and going back over what he had said about hoping for the long term cure, I believe he was holding to that hope by prolonging the hospitalization and morphine drip as long as possible.

About three hours after I had arrived, he returned from the bathroom and said, "I'm ready." He had been carefully monitoring his urine color. He said he was dehydrated and needed an IV. This brought us to Darnall Army Community Hospital on a late afternoon in January, 2000.

Remaining the soldier in charge he orchestrated his care. When the blood transfusion was stopped after two pints he held up four fingers, "The order was four," he said.

"I know, Sir," the nurse replied. "We'll do the others later."

A short time later, he removed the oxygen mask from his face and said, "I'm gasping." The attending nurse seemed not to hear, and he repeated in a more forceful voice, "I'm gasping."

The life support machine had already been placed near his bed. Pointing toward the machine, the nurse said, "Sir, you know what it means if we hook you up to the machine."

He replied, "Yes, give me five minutes with Mom." During that five minutes Barry and I had our last talk. I held his hand and soothed his brow as I had done so many times as he grew up. (It is a feeling of helplessness, an agonizing defeat of motherhood, seeing your child suffer and you cannot help). This time I needed his strength, and he did not fail me. Then he said, "Hook me up, but when the family all get here, turn it off and I'm out of here."

———

Barry was admitted to the Intensive Care Unit approximately thirty-six hours before he died. The admitting doctor never left ICU during those hours. Although other doctors came to take up the shift, this doctor was always there, merely stepping aside. It was he who reported on what was happening. The head nurse also never left the shift. Once during the ordeal I asked when she was going home, and she said, "After awhile." It was she who prepared me for the

support system being turned off, and held my hand. During this time she slipped something into my pocket, giving me a slight pat. Later I read this message.

To All Parents

"I'll lend you for a little time a child of mine," He said.
"For you to love the while he lives and mourn him when he's dead.
It may be six or seven years, or twenty-two or three.
But will you till, I call him back, take care of him for me?
He'll bring his charms to gladden you, and shall his stay be brief,
You'll have his lovely memories as solace for you grief."

—Edgar A. Guest

In October 1999, Barry returned to Fort Hood after two years in Germany and was assigned to a new unit. Because MI is a small group with the soldiers serving at a few posts around the country, and because, as I was told, they rotate among the posts, they often cross each others' path. Many of these soldiers who stood the vigil with me had served with Barry at sometime during the last twenty years. It was through these men, I got the first glimpse of my son, the soldier. I listened with pride as his teammates praised his leadership and devotion to his work. I heard them talk about the soldier they knew, and respected.

We talked about his hometown, and about his love for Oklahoma. We talked about his red truck with an Oklahoma Sooners bumper sticker. We talked about the second Saturday in October as being like a holiday to Barry—the date of the Oklahoma University vs Texas University football game. We talked about his interest in the Civil War, and how he would equate events of that war to current situations. We talked about his humor and his ability to see humor in life. Occasionally one would choke up as he/she shared memories with me. "It's tough to let go." One said.

The Chaplain told about serving with Sgt. Hudson in Augsburg back in 1981. Saying he was a private at the time, and that it was only later he decided to become a chaplain. He had not caught up with his former sergeant at Hood until he heard of his illness. "I'm glad I can be here for him, because he was there for me, encouraging me to take the steps to become a chaplain."

At one point during the day, I developed a headache, and asked the nurse if there was any way she could get me a Tylenol. The desk nurse said she couldn't give me one, but she could drop one on the floor and I could pick it up. One of the soldiers heard this and said, "I'm on duty, and I have a headache." The desk nurse gave him a packet of Tylenol for his headache, which he quickly handed to me as the desk nurse gave me a glass of water. Throughout the day headaches

were developed to keep me supplied in Tylenol. This was one of the lighter moments but it shows how attentive the unit was toward their Sergeant's mother. This is something I will never be able to repay, but this kind of devotion does not know how to react to repayment.

———

Someone once remarked to me that Military Intelligence was an oxymoron. I have bristled at this remark ever since. In researching and collecting material for this tribute to a soldier who valiantly served in the Army Military Intelligence for twenty years, I hope to put to rest not only my annoyance at that expression, but to share the dedication, and esprit de corps that I came to understand and appreciate.

It is in search of my son, the soldier, that this work is approached. It is for you the reader to come to appreciate those who serve with dedication.

———

A man who has been the indisputable favorite of his mother keeps for life the feeling of a conqueror, that confidence of success that often induces real success.

—Sigmund Freud

Chapter One

MILITARY INTELLIGENCE

Intelligence is the art of knowing one's enemies.[1] The method of practicing this art in the United States Army has run the gauntlet, and probably has not until recent years reached a plateau of readiness.

Some form of Military Intelligence has existed as long as there has been war, or any confrontation between peoples. Historians and novelists, alike, have filled volumes describing the Indian and civilian scouts on the frontier, Mexican bandits and deserters who served as spies on the Mexican border, and Benedict Arnold type spying from the American Revolution, all performed an intelligence function. However, Military Intelligence as an organization with a defined agenda within the United States Army can date back only a few decades. Reaching this position of professional recognition has been long in coming.

The idea of Military Intelligence seems to have had a more pressing need on the European Continent. Waves of this strategic warfare slowly drifted across the Atlantic. The isolation of the American Continent did not demand an immediate need to keep an eye on one's neighbor thus the command of the small U. S. Army saw no purpose for intelligence gathering in the European fashion. It was not until after the American Civil War that the first division of military intelligence came into being but this beginning will hardly survive the birthing bed. A chance of a rebirth came in World War I when the American Army found it necessary to adjust to fighting a war on the continent of Europe, where the skill of knowing your enemy was a necessity. At this time an intelligence division including intelligence officers in all units down to the level of battalion became a part of the War Department General Staff. Counterintelligence became a tactical operative weapon. Military Intelligence expanded to become a "shield" as well as a "sword."[2] The struggle to find a home of their own and for professional recognition was not yet a reality. Intelligence collecting was shared with various Signal Corps within the Army and carried out by nonintelligence personnel.

In the peace era to follow, intelligence continued to face an identity crisis, on the one hand, "What was it's function?' and on the other, "Is MI important enough to the Army's role to merit separate recognition?" This latter question was somewhat answered during the World War II era when the army created an intelligence structure that provided for training across a spectrum of disciplines. The move led to the recognitions of the importance of communications

[1]Finnegan, John Patrick. *Military Intelligence.* Washington D. C. Center of Military History United States Army, 1998. Forward.
[2]Finnegan, p4.

intelligence that resulted in a transfer of the Army Signal Corps intelligence gathering to Military Intelligence.

By the close of World War II, Military Intelligence reached a position of legitimacy, but the task of catching up to years of lost time was just beginning. The involvement in the Korean and Vietnam wars saw Army Military Intelligence move to the top of the flow chart, as foreign intelligence collecting, and photographic intelligence filled in the boxes on the chart. The second class citizen syndrome continued to frustrate the command, however, as is most often the situation when the budget lags behind, thus hindering growth.

In 1987, the chief of Military Intelligence declared, "Army intelligence has arrived."[3] On July 1, 1987, the activation of Military Intelligence Corps at Fort Huachuca, Arizona declared that all military intelligence personnel to be a part of the United States Army Regimental System for the purpose of promoting espirit de corps. This concept organized all personnel into the same regimental organization. Three distinct segments of army intelligence were united together to perform all intelligence for commanders from the United States President on down.[4]

COAT OF ARMS

The coat of arms worn by our military are badges of identity, the origin of which dates back to the Middle Ages when the use of heavy armor made it difficult to distinguish friend from foe on the battlefield. This colorful heraldry is symbolically designed to depict the history, traditions, ideals, mission and accomplishments, and is an important factor in promoting the espirit de corps. The motto, unsually shown on a scroll, originated from war cries and alludes to the specific strength and purpose of the unit. The use of crests in the United States Military has a short history, with the shoulder sleeve insignia, as currently familiar, originating during World War I. During the Civil War and the Spanish American War crudely drawn symbols, usually from a single piece of cloth, were worn on soldier's headgear and adorned unit flags. These symbols served as recognizable markings of identity and pride. The authorization of the use of symbols worn by the military in the form of sleeve insignia and other coat-of-arms identification markings has expanded as the United States Military organization has developed a professional pride. The shoulder insignia and motto badges shown on the following pages are those of the units in which Barry served.

[3]Finnegan. p.196
[4]http://www.fac.org/irp/agency/army/mi_corp/ Pike

MILITARY INTELLIGENCE
CORPS REGIMENTAL
INSIGNIA

The Military Intelligence Corps crest is an oriental blue shield with a gold sphinx superimposed over the crossed key and lighting bolt. Below the shield on a scroll is the MI Corps motto, *"Always Out Front."* The oriental blue and silver gray colors associated with military intelligence represent coolness and courage.) The three basic categories of intelligence – human, signal, tactical – are symbolized by the sphinx, key, and lightning bolt - the wisdom and strength of the sphinx, the security and control of the key, and the electronic warfare capabilities of the bolt of lightning.

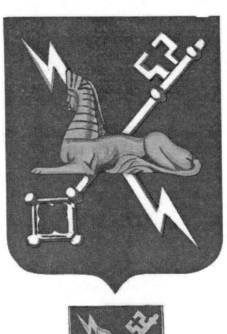

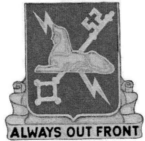

3

1st Military Intelligence Battalion
Augsburg, Germany

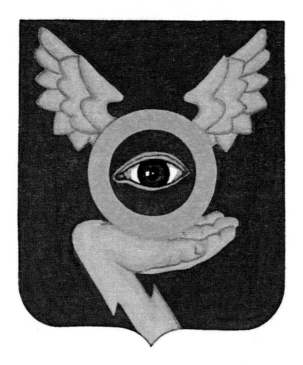

We labor to inform the Latin *Informare Laboramus,* the motto of the 1st Military Intelligence Battalion identifies the unit's total mission. The colors teal blue and yellow belong to the air reconnaissance support battalion. The aerial photo interpretation mission which is an important part of the unit's history is symbolized by the annulet as a camera lens. The wings refer to flight, the eye to observation and the flash alludes to the signal elements of the unit. The hand commerates the unit's mission to support.

101st Military Intelligence Battalion
Fort Riley, Kansas

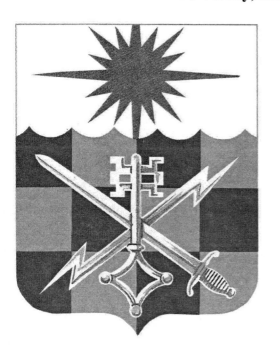

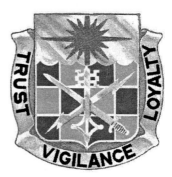

Amid the traditional Military Intelligence colors of oriential blue and silver gray a sunburst gives reference to the unit's multi-factional radio function in the atmosphere. The chessboard like background alludes to the strategy and intelligence of the game. The sword is the unit's military ability, the flash represents speed and communications, with the key symbolizing intelligence and security. The unit's motto *Trust Vigilance Loyalty* is scrolled as a flame around the badge.

15th Military Intelligence Battalion
Fort Hood, Texas

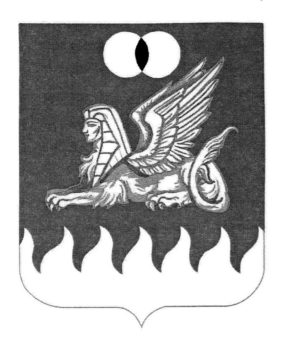

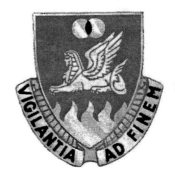

Barry was attached to Company B of the 15th Military Intelligence Battalion at Fort Hood, Texas during his first assignment to that post. This unit was activated in April 1978 at Fort Hood. He wore this insignia to Desert Storm.

The all-seeing and continually watchful winged sphinx affixed to the traditional Military Intelligence oriental blue and silve gray background, refers to the batallions's air reconnaissance support mission and connotes the unit's motto *Vigilance to the end.* The unit's stereoscopic capabilities provided by the proformance of reproduction, identification, and packaging of aerial imagery are symbolized by the overlapping discs. The use of heat sensory devises as well as wisdom and zeal are represented by the flames.

111th Military Intelligence Brigade
Fort Huachuca, Arizona

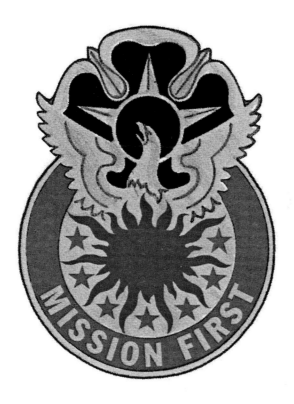

Barry was attached to Company I, 305th Military Intelligence Battalion, 111th Military Intelligence Brigade, at Fort Huachuca, Arizona.

The gold heraldic rose symbolizing military intelligence's basic mission — to collect, check, and make available any information about a present or possible enemy — is positioned at the top of the design to illustrate the unit's motto *Mission First.* The unit's history is remembered by the phoenix rising out of flames. The original location, Atlanta, Georgia, and the seven states where the unit has operated are depicted by the ring of oriental blue stars.

205th Military Intelligence Brigade
Wiesbaden, Germany

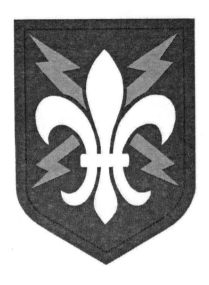
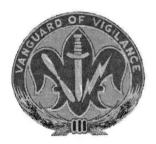

In his picture taken during his last Germany tour Barry's shoulder sleeve insignia is that of the 205th Military Intelligence Brigade.

On an oriental blue shield a white fleur-de-lis is centered in front of two crossed silver gray lightning bolts. The oriental blue and silver are the colors associated with military intelligence. The crossed lightning bolts refer to the convergence of all types of intelligence from all sources enabling the commanders to *"see the battlefield."* The unit's historical original activation in France is alluded to by the use of the fleur-de-lis. The motto of the 205th is *Vanguard of Vigilance.*

One of the most self-satisfying times of Barry's military career was the time spent wearing this insignia. His life seemed to be taking direction. He felt he had accomplished his task.

104th Military Intelligence Battalion
Fort Hood, Texas

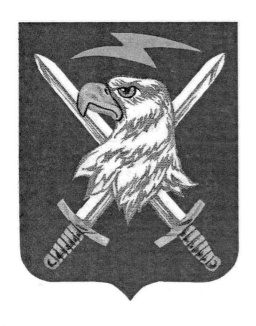

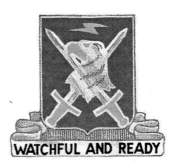

WATCHFUL AND READY

 Barry arrived at Fort Hood, Texas and was assigned to the 104th Military Intelligence Battalion in October 1999. This was to be his last assignment before retirement. He hardly had time to get accustom to his new insignia before taking ill. Although he was sorta the new kid on the block, he was accepted and respected as a career soldier. They proved their loyalty as they stood his last watch with him. He was laid to rest wearing the insignia of the 104th MI Battalion.

 The cross swords amid the oriental blue and silver gray attest to the unit's readiness, while the wide-eyed and alert eagle symbolizes watchfulness. The unit's electronic warfare capabilities are referred to by the bolt of lightning. Combined, the symbols express the words of the motto *Watchful and Ready,* the basic mission and responsibility of the unit.[5]

―――

While preparing this material on the history of the United States Military Intelligence, I heard an interview of Shelby Foote, the novelist and Civil War

[5]Finnegan. Heraldic Items. pp 213-420.

Geneva Johnston Hudson

Historian, who when asked about intelligence during the Civil War, indicated the weakness of that art of warfare, and completed his thought by expressing that Americans adversity to spying is a product of our ideas of independence and privacy. He ventured that this form of warfare would continue to be our weakest link in the attention given it.

Chapter Two

THE BOY SOLDIER

Looking back on Barry's life, I can see the soldier, he will become, developing. He was not more than four years old when a TV series titled *The Rebel* caught his attention. This action packed Civil War drama was filled with battle scenes and heroism. This series was one of the first of a number of Civil War stories that will become choice entertainment as the nation entered the centennial years of that great conflict.

Barry's interest in the Civil War deepened as he and I raided the library shelves for stories. He quickly learned to read those from the children's section, but his hunger was not satisfied, so I selected from the adult section for him. His attention was turned to books of photography, maps, and battle scene layouts. He knew the major battles, weapons, and players. He was pro Yankee, but showed a respect for the Rebs, as though they were in competition on a playing field, instead of a deadly conflict. For Christmas the year he was five, I found via a catalog a 200 or more piece set of pliable plastic Civil War soldiers, cannons, bridges, trees, everything necessary to set up a battle scene.

At this time we were living in Liberal, Kansas in a rented house that was very old, but also very large. There were more rooms than we needed or could fill with furniture. One room became Barry's Civil War room. He used the entire floor space to design his battle scenes, carefully following a diagram or picture from a book. Hours and even days were spent getting the battlefield ready for Shiloh, Gettysburg, Antietam, or other. When he would call, "Mom, come see my battle," soldiers both blue and gray were strewn about, bridges down, weapons in ruin. Just as carefully as he had followed the diagram to set the scene, he had conducted the battle depicting the devastation of war.

A tour of the Civil War battlefields, when he was six, was an experience Barry had expressed a desire of repeating sometime later in his life. Starting at Pea Ridge in Arkansas where he 'charged' down the sloping hillside of the plush green lawn around the museum, then to Shiloh, Antietam, Fredericksburg, and Gettysburg. He collected souvenirs, brochures, and spent much time discussing the battles, generals, and scenes with the Park Rangers. As you read his work you will see that the terrain of those battlefields made a memorable impression on his young mind.

There came a time when his plastic soldiers were put away in an old metal suitcase; stored in the attic maybe for his son or grandson or to rekindle those youthful memories in his old age.

The little toy dog is covered with dust,
But sturdy and stanch he stands,
And the little toy soldier is red with rust,
And the musket molds in his hands.
Time was when the little toy dog was new,
And the soldier was passing fair,
And that was the time when our Little Boy Blue
Kissed them and put them there.

— Eugene Field

The toy soldiers were put away but his love of the strategic planning of battle was never given up. Entering the little league age, he substituted the toys for balls. Playing little league football was determined more by size than by age, and Barry was large enough to play on a team with older boys when he was seven years old. Immediately, he learned the plays. Strategy is strategy whether on the ball field or the battlefield. We were especially thrilled when the coach came to tell Barry he wanted him to be the Captain of the 1st game. Although Barry was the youngest on the team he was given the quarterback position, because the coach said he could execute the plays so well. Football soon proved not to be Barry's game, however.

Yes, he could execute the plays flawlessly, but he was not rough enough. He could get through the hole in the line, but he was not rough enough to continue for yardage. I suppose being an "only" where he never had to compete by roughing it up with a sibling was his problem. At any rate his football career was cut short at the second grade level. He continued to play little league baseball through elementary years, but somewhere along the way tennis became his game. He played tennis during his high school days.

His leadership talent began to emerge after we moved to Edmond, Oklahoma when he was in the fourth grade. There were a number of neighborhood boys near his age, and he soon took charge in organizing them into games. On a beautiful weekend morning, or a sunny summer day, Barry would get on the phone and call the "lower east side" gang for the game of the day. The choices were touch football on the median, soccer on the abandoned field on the college campus, stick hockey in our garage, or basketball in the backyard of a neighbor who happened to have a goal that had been placed there years earlier for her son.

In high school, he became an avid reader, a writer and an independent thinker. With an undefeatable spirit and a sharp wit he was somewhere on everyone's sociogram of friends. It was at this age that he began to develop an affinity for the unfortunate. Bigotry, racism, sexism, intolerance all became his enemy. A beautiful young woman in uncontrollable tears approached me at Barry's celebration of life ceremony. "I loved him so," she said. Then she told

12

me a story of how Barry had befriended her when they were in high school. Seems she was one of the "poor" girls in a rather "rich community" high school, and as such was the target for the letterman's club initiation. The guys were to flirt with her and then kiss her. "Without saying a word, Barry took off his letter jacket (newly awarded for tennis), and stepped between me and the jocks," she said.

Barry always had a good relationship with his teachers and accepted the challenge to develop his thinking skills. He questioned what he did not understand or had problems believing. From American History teacher, Cheryl Apple, he learned to look at history as drama and to accept the cause and effect philosophy. He appreciated the mathematical discipline taught by Lucille Peters, and although the literature class with Jeanie McBride often stirred his ire, he later put to use the literary skills she insisted he accept. It was in Judy Palmer's (Ackerman) journalism class that he found a mission - the responsibility of a free press. He counted it his responsibility to use his mind and talents to right any wrong that crossed his path of life.

In the fall of 1973, with a McMahan journalism scholarship in hand, Barry was off to Oklahoma University, where he settled in as a student and became devoted to *The Sooners.* He was serious about his education and was often on the Dean's Honor Roll, or the President's Honor Roll. His visits home were mostly for the necessities, money and laundry. Thomas Wolfe wrote *You Can't Go Home Again,* and in some sense Barry was never home again. Not because he had changed, but because home had changed. It was no longer a place where Mom and Dad made the rules and who were respected because they were his parents. Now the playing field was more equal, it was adult to adult. Home was a place he liked to be, a place of comfort, a place to go because he wanted to be there. The boy had become a man.

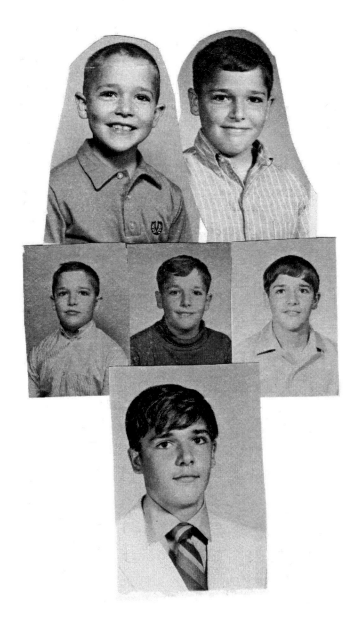

collection of childhood photos

Chapter Three

THE MAN SOLDIER

In serach for my son, the soldier, I acquired the help of the U. S. Army Intelligence Center at Fort Huachuca and his military records from U. S. Enlisted Records and Evaluation Center in Indianapolis. It is in these records I found the soldier. This chapter contains a collection of remarks from evaluation reports submitted by his immediate superiors. In all these pages, evaluations made over a period of nearly twenty years, nothing negative is recorded. I cannot say I am surprised, because I knew the kind of boy he had been and the man he had become, but now I know that those characteristics he demonstrated from his youth grew even stronger in the man, the soldier.

After enlisting, Barry attended boot-camp at Fort Chaffee, Arkansas and then attened Defense Language Institute (DLI) in Monterey, California. Upon completion of the Russian Language program and instructions in voice radio at Goodfellow, Texas, he started on a Military Intelligence journey that will take him through four wars — Cold War, Desert Storm, Bosnia, Kosovo.

To protect their privacy, I am not including the names of the men and women who signed the evaluation records from which the following comments are excerpts. I purposefully included comments in which the language is similar so that the reader could see the consistency in the dedication of the soldier.

From my observation it appears evaluations are made to cover a two year period and are often concluded with a recommendation for promotion. Three superiors are involved in each evaluation. First Sergeant as evaluator, Sergeant Major as rater and indorsed by commanding officer, who sometimes added comments.

As per contract agreement upon completion DLI, Barry entered into his duties as a sergeant.

Augsburg, Germany - 1st Operations Batallion (1982-1986)

Barry's asignment in Augsburg was to operate sophisticated computer-assisted equipment configurations to intercept, identify, and record designated voice radio signals. He supervised eight personnel in the collection of voice and non-voice transmissions.

During this four year tour in Augsburg, evaluation comments were highly positive. He was praised as an outstanding individual both as an operator and as a soldier.

He is the type of soldier that can accomplish any task set before him. His knowledge is exceptional and he has worked hard to become one of his platoon's most competent operators. He has taken an active role in the training of his fellow soldiers, and has the respect and admiration of his peers and superiors and is rated the highest caliber of soldier. He displays a high degree of self motivation and a positive attitude which has a positive effect on those with whom he works. SGT Hudson is a credit to his organization and the United States Army.

He was praised for his work to instill in his soldiers an enthusiastic will to work, especially in a section filled with new inexperienced operators. He was selected over more senior personnel to fill a supervisory/leadership position and was lauded for the performance of these duties. It was noted that this was under constant pressure of increased mission requirements and administrative pressure.

He is considered the mission expert within his area of operations, and as such, has been selected to assist in the research and publication of a comprehensive training program for the overall mission.

It is interested to note that Barry is considered experienced above others when he has not yet completed his first enlistment period. He seems to have wasted little time putting his innate drive to excel into high gear. As his abilities became recognized his duties and responsibilities were expanded. He became a trainer for prospective Chief Voice Operators across shifts other than his own. As Battalion NCO he was responsible for ensuring that over four hundred soldiers received adequate training in the safety and protection necessary against biological chemical weapons. "Once again he became the trainer for all the platoon representatives, and once again, the job was superbly accomplished," an evaluator wrote.

Sgt. Hudson is the most knowledgebable supervisor of his subsystem across four shifts. If there are any questions concerning his mission, he has the answers. When they have questions, the analysis section frequently asks him for assistance, and his answers and opinions are respected. During mission awareness he is the soldier who can get the job done. He is decisive. He knows what he is doing. His integrity and loyalty are above reproach.

His unique ability to communicate was credited for his teaching skills in which his subordinates were taught to perform to their maximum potential.

> Sgt. Hudson has earned and deserves the accolades given him by both his peers and superiors.

The four years Barry spent in Augsburg were important years in the Cold War. In a conversation I had with him after he had completed his last tour of duty in Europe, shortly before he was to retire, he told me that the most important work he had done during his twenty years service, was those Cold War years. He said, "I am proud of our accomplishment. This was MI's war and MI's victory." When you read his journal *Ghosts of the LTHA,* in this work, you will come to understand why he felt this. The above evaluations will also clue you in to his dedication to that mission.

Returning to the States after the Augsburg tour, he attended DLI again for the advanced course in Russian. Upon completion of that course, he was assigned to Fort Riley, Kansas, and was promoted to the rank of Staff Sergeant.

Fort Riley, Kansas (1986)

At Fort Riley, Barry was recognized as an intelligent competent noncommissioned officer and was lauded for his great working knowledge of Electronic Surveillance Measures Operations and Job Requirements. During a field exercise to Fort Huachuca, his leadership was credited for accolades directed toward the 101st Military Intelligence Battalion - his unit.

> SSGT. Hudson possesses the inate ability to anticipate and initiate the required and correct response to any situation. He is precise and positive in carrying out his assigned duties.

Fulda Gap, Germany (1986-87)

A second tour of duty sent Barry to Germany again. This assignment took him to the Fulda Gap, an area bordering the East/West division line. He said that perhaps if his life was ever in jeopardy it might have been during these heated days of the Cold War, so near the Berlin Wall.

In addition to his MOS as Senior Voice Intercept Operator, he served as NCO for an Electronic Warfare Helicopter team, responsible for training, maintenance, and operation of electronic warfare equipment and ground support equipment. He also provided technical training including Russian language training for the platoon.

SSGT. Hudson is the most technically proficient voice intercept operator assigned to this Regiment. His expertise is often called upon by the regimental operations officers. He has provided technical training to personnel assigned to the 511th Military Intelligence Company in addition to members of this platoon. He was instrumental in establishing the platoon's ground equipment maintenance program.

SSGT. Hudson is an outstanding noncommissioned officer and is without a question the most proficient Russian Linguist in the 11th Armored Cavalry Regiment, being often called upon by the Regimental Operations Officer to help with difficult Russian interpretation.

One comment read, "In addition to his being an expert voice intercept operator, he is an excellent teacher and leader."

Enough of war and separation from family! Barry returned from Germany with a desire to leave the army after ten years. He wanted to pick up his education where he had left it, and begin the quest for his dream of becoming a college professor. However, it became apparent that the hefty bonus being offered by the army for him to re-enlist was something he could not match in the private sector at that time. He put away his dream and took up his sword. This decision was perhaps a turning point. This was when he really became a soldier. Although he had added his signature to all the evaluation papers that praised him as a teacher, his humility perhaps prevented him from seeing that he had already attained his goal, though not on a college campus.

Fort Hood, Texas (1988-89)

Barry reported to Fort Hood, Texas to begin his new enlistment. Here he was given the responsibility for monitoring, identifying and reporting highly perishable information needed to satisfy the intelligence requirements of the III Corps Commander. He also performed duties as a Flight Operations NCO responsible for the supervision of two soldiers in maintaining flight records for twenty pilots and the unit flying hour program.

SSGT Hudson's dedication and motivation are contagious. He is a valuable instructor in Troyan and Total Language, and eagerly shares tactical expertise. He has established a program for tracking pilots and aircraft flying time, improving Guardrail V mission's scheduling. He possesses unlimited potential.

During this evaluation period Barry was sent to Fort Huachuca service school. He was administratively relieved due to being recalled by his unit in support of Operation Desert Shield. For his brief stay at Huachuca his service school academic evaluation report read.

> SSGT Hudson's grade point average after five weeks was 97.69%. In my opinion he would have exceeded course standards if he could have continued his studies.

Operation Desert Shield/Storm (1990-92)

Looking at Barry's record it is readily clear why the call to War reached out for him. His leadership was needed. Not one to write lengthy letters home to Mom, the few I received were welcome news. He complained about flies and fleas and wasted time trying to shovel all the sand of the desert into bags during Desert Shield. During Storm his letters reported how busy he was, need for sleep, and that he was safe.

It was reported that he trained over ninety American and Kuwait soldiers to operate communications intercept equipment. He was commended by his Brigade Commander for intelligence provided during an exercise called "Distant Hero."

> SSGT Hudson shows genuine concern for soldiers and is constantly teaching. He stands up for what is right and can always be counted on to give an honest opinion. He constantly stresses safety and takes responsibility for his actions and the actions of his soldiers. He sets the example - be-know-do. He has trained ten soldiers to achieve first time "go" on CIT test.

These strong words of character bring tears to my eyes, and leave an empty spot in my heart. I am so proud.

Fort Hood, Texas (1992-93)

Home from Desert Storm and promoted to Sergeant First Class, Barry continues to be acknowledged for a job well done as a soldier.

> SFC Hudson is unafraid of rendering hard decisions despite personal risks. Absolutely professional in manner and behavior, both on and off duty. He instituted and led a rigorous platoon physical fitness training program and has consistently received the Commander's physical fitness award. SFC Hudson is an

19

excellent leader, trainer, and mentor with exceptional diverse knowledge and technical expertise.

His assignment information stated that he shouldered the responsibility for 100% accountability/turn-in of Guardrail V System components valued at 100 million dollars.

Fort Huachuca, Arizona (1993-95)

Barry's name came up again so he could finish his training at Ft. Huachuca, and his duty assignment was also transferred there. His MOS at Huachuca was senior instructor/writer. During the next two years his duties were in the supervisory category, developing and maintaining lesson plans for team combat survival techniques and procedures including site selection, land navigation and communications. (Because I am a teacher, Barry often shared his ideas for lesson plans with me).

SFC Hudson planned and executed logistics and training for seventy-two hour, thirty-four soldier field trip. He sets an example in personal and professional conduct and is committed to training soldiers. He has no equal. He mentored one of his instructors to win instructor of the month and Warrant Officer Candidate selection. He supervised and mentored Junior ROTC students on the Leadership Reaction Course.

Other comments in this evaluation included a mention of his having rewritten two lesson plans for common block classes, and leading a team that won Brigade-level Language Olympics competition in Russian Language.

Bad Aibling, Germany (1995-97)

Barry returned to Germany in the fall of 1995 for a two year tour. Upon returning to Ft. Huachuca in 1997, he placed his name on the roster to return to Germany for a final tour. He wanted to end this final tour in Germany early enough that he would not be overseas when his retirement came up in February 2000. Thus he did not wait the required six months time between tours. He returned to Germany in the fall of 1997.

Wiesbaden, Germany (1997-99)

A mature determined man left for Germany on this his last tour. He was excited about reaching the top of the NCO ranks. He was now a Master

Sergeant. Completion of his twenty years was now his goal. He was assigned to the 205th Military Intelligence Brigade of V Corp in Wiesbaden. Now a mature soldier who had paid his dues in war both cold and hot, he was a valued asset to the 205th because of the U. S. involvement in the Balkans problem. He supervised the conduct of the Brigade Emergency Operations Center which successfully deployed over 300 soldiers to the Balkans. As Brigade Operations Sergeant Major of a forward-deployed Corps Tactical Military Intelligence Brigade composed of three battalions, he lead, trained, and supervised soldiers in the areas of maintenance, readiness, and operations while assuming responsibility of all brigade staff sections during deployment. He designed and implemented a program to take full advantage of automation in the TOC, and developed a mission training plan to support the S3 Section METL. He supervised a team of collectors, linguists, and analysts using state-of-the-art multi-million dollar SIGINT equipment to perform highly critical missions of providing timely intelligence to national and theater level decision makers, tactical information, indications, and warnings on a 24/7 basis.

I came across an item while researching that I'm sharing, although there was nothing in Barry's records to indicate his direct involvement in such a situation, it is the work of SIGINT which is Barry's MOS. The Article was titled *Bosnians discover GIs listen,* and was submitted by Rick Atkinson on the internet with a copyright 1996 Houston Chronicle notation. It is a simple reference to a SIGINT operator picking up a surprising Serb military radio broadcast, that when decoded helped discover a Serb violation of the NATO accords. It seems that the Serbs were surprised to discover that the 205th SIGINT really listened to them. A high ranking officer of the 205th is reported to have said, "They know we're the best in the world at signal intelligence."

Barry came home for his Dad's funeral in March 1999. I saw a relaxed happy man, getting ready to take hold of his life, and accomplish his dream. During those few days, he talked often of where he was going. In retrospect as I'm searching for the soldier, I caught a glimpse during those days. I saw him in his dress uniform proudly explaining the decorations, and symbols. I saw the tender way he received the flag that had draped his father's casket. Yes, it was my son who sat beside me that day, but it was also The Soldier.

———

"If hate is what we're fighting for, then I don't want to win." "Did you hear that? That's a great statement!" Barry proclaimed pointing toward the TV. "These senseless religious, ethnic-cleansing wars in Bosnia, Kosovo, Ireland, Israel or where ever, are led by some power hungry idiot who feeds them this hatred." He expressed his feelings in anger.

"Think about it, Mom," he continued. "We're a young nation compared to those countries, and look at the pockets we put people into — Christian Coalition, Rainbow Coalition, Black Caucus, Jewish Community, Women's League, etc — all led by some power hungry idiot who reacts to difference with hate. Racism, sexism, religious bigotry, liberal, conservative, are the terms fed into our thoughts with every newscast, separating us into pockets of hate."

My memory of that outburst of feeling is vivid. Looking back on those moments and in my search for The Soldier, I find he was truly sworn to protect and defend his country against all enemies. He was Military Intelligence converging information to see the "battlefield." His MI training picked up the signal — intolerance is the enemy.

Chapter Four

MEMORIAL TRIBUTE
TO MASTER SERGEANT BARRY K. HUDSON

by: Lietenant Colonel William J. Tait, Jr.
Commander, 104th Military Intelligence Battalion
February 2, 2000

Brigadier General and Mrs. Higgins, Colonel Kostich, friends and family of MSGT Hudson, fellow outriders, and soldiers, ladies and gentlemen.

It is an honor to join with you today to remember a great American soldier, MSGT Barry K. Hudson. Born almost 45 years ago in Guymon, Oklahoma, this terrific leader grew up well in America's heartland and unlike most soldiers who enlist, got his college degree before joining the Army. That education stood him in good stead and set an example to emulate for generations of Army Intelligence soldiers, especially those in his chosen field of Signals Intelligence. Barry Hudson mastered the Russian language and eventually trained to proficiency as a Sero-Croatian linguist. Besides his language training at the Defense Language Institute's California and Washington D. C. campuses, MSGT Hudson did intelligence coursework at Goodfellow Air Force Base, Texas, Fort Huachuca, Arizona, and Fort Devens, Massachusetts. He excelled in Military Intelligence assignments at Fort Riley, Kansas, on multiple tours in Germany, as an instructor and troop leader at Fort Huachuca, and during two tours here at Fort Hood. He is a decorated veteran of the Cold War, Operations Desert Shield and Desert Storm in Southwest Asia, and stability and support operations on the ground in Bosnia. With that stellar military career behind him and looking forward to Army retirement followed by a new civilian life, MSGT Hudson reported to our unit four months ago. This was his second tour at Fort Hood — The Great Place. He was instantly an inspiration to all of us with his pledge to soldier hard until his last day in uniform. That convinced CMS Brown and me to assign him as Operations Sergeant in the Analysis Control Element — ACE. MSGT Hudson proved himself and us right, excelling every day in what is perhaps the toughest and most vital tactical intelligence job a MI NCO can do. He was key to providing vital intelligence to combat commanders and setting the Army standard of excellence for Force XXI intelligence operations. That is a significant legacy. But most important and lasting was his impact on soldiers. You'll see what I mean when SSGT Benning and SFC McClenton speak. Barry Hudson's finest legacy is his great American family. When you meet them it is immediately apparent that besides being a very lucky man, Barry Hudson was a fantastic husband, father, and son.

Most of us have heard the famous words spoken by General of the Army Douglas MacArthur many years ago, "Old soldiers never die, they just fade away." MSGT Barry Kent Hudson was young, vibrant, and excited about the future when he left this life. He honored his promise to soldier to the end. Our memory of him will be intense and inspirational throughout life on this earth, never fading before we join him in that Greater Place.

I have one additon to the program that is not listed in your bulletin. It is a tribute sent by the Command Sergeant Major of MSGT Hudson's previous unit — the 205th Military Intelligence Brigade of V Corp in Germany. MSGT Hudson served with distinction as the Operations Sergeant Major of that Brigade. CSM Kurt A. Richer writes:

> MSGT Hudson lived life to its fullest. I cannot remember a time when he did not have a good word to say about someone or something. He approached everything with a zest and enthusiasm that motivated his soldiers to accomplish things they though they could not do. The Army and our soldiers have lost a true mentor, coach and friend in MSGT Hudson's transition to the next life. He was a selfless servant to our nation and we are all better people for having had the opportunity to know him. He served the 205th MI Brigade S3 SGM for two years and enhanced its ability to deploy and go to war. He was an innovative thinker and adminstrator who brought the Brigade into the age of technology to leverage its ability to provide the V Corp Commander with the intelligence required to be victorious on the battlefield. Most of all MSGT Hudson was a genuine human being who truly cared for his soldiers and lived the profession of soldiering. We will truly miss him.

———

On Friday when I was asked if I would speak today, I was honored, but hesitant. What could I possible have to say? Then I thought about it this weekend and out of the million conversations I have had with MSGT Hudson the only one that kept coming to my head was about retirement.

After the E-7 list had been published and I wasn't on it, I was very upset. I had told MSGT Hudson that there was no way I would retire as a Staff Sergeant. MSGT Hudson sat me down and said you know it isn't about RANK, AWARDS, or how much you get paid. If after 20 years you know in your heart you did your best, and gave your all, and influenced at least one soldier in a positive way, then you hold your head up high and know you did your job. He stated he was privileged, and I could never figure out why? Until one day when I asked him

SEARCH FOR MY SON - A SOLDIER'S STORY

what he meant, and he just said four words, TO WEAR THIS UNIFORM! TO WEAR THIS UNIFORM!

Well, MSGT Barry K. Hudson, know this, you did it right. You gave your all. And most importantly you influenced at least one soldier. Me!.

Thank you and God bless.

—SSGT Benning

————

A Eulogy for MSGT Barry K. Hudson

by: SFC D. E. McClenton

In a speech given at the end of the Cold War, President Bush said,

> To the brave men and women who wear the uniform of the United States of America — thank you. Your calling is a high one — to be the defender of freedom and the guarantors of liberty.

On that day, President Bush was speaking directly to soldiers like Master Sergeant Barry K. Hudson.

Shortly before his death, Master Sergeant Hudson said that the proudest accomplishment of his life was the role he played in America's winning of the Cold War. As a Russian linguist and Electronic Warfare Signal Interceptor, he spent several years of his career in Europe, proudly serving on the front lines of the Cold War. America's commitment bringing peace to the people of Europe was forged through the perseverance and dedication of brave soldiers like Master Sergeant Hudson. This peace could not have been achieved without the efforts of people like Barry Hudson, and for that we thank you and we salute you.

When I met Master Sergeant Hudson last October, I gained a role model. In his nearly twenty years of dedicated service, he took his commitment to our nation seriously and readily accepted all obstacles and challenges he faced. As a soldier, inherent among those challenges was the requirement to spend innumerable days and night away from family and loved ones. Master Sergeant Hudson fulfilled that requirement to his beloved nation to the very end. He was a proud soldier who was preparing to close the chapter on his military career.

Master Sergeant Hudson's life came to an unexpected end before he was able to reach his goal of retiring. However, let us use his career and his life as an

example of what each of us should strive to achieve before we, too, are taken from this earth. His life ended, but his impact on our lives is immeasurable. His role as a defender of freedom and a guarantor of liberty has made the world a safer place, and his legacy will endure for his children, his children's children, and for generations to come.

Barry Kent Hudson

MSGT Barry Kent Hudson fought his last battle against the deadly enemy, Carcinoma unknown primary (CUP) and stopped the bullet with his name on it at 9:30 PM January 27, 2000 at Darnall Army Hospital in Fort Hood, Texas. He was 44 years old. He had not been ill prior to November 1999.

A Military Intelligence, Russian Linguist, Barry was a veteran of the Cold War having served in Augsburg and Fulda Germany during that crisis. He considered this his greatest victory, but always hastened to add there is no ribbon on my chest to depict this victory, nor any momument in Washington. "Our wall has been torn down. It was MI's war and our victory, making the United States the most powerful nation in the world." He often said.

A dedicated soldier, Barry was proud of his unit and their accomplishments. His unit 104th MI BTN "outriders" demonstrated this pride as they stood a silent thirty-six hour vigil as their comrade completed his final mission.

He fought the flies and fleas in Saudi Arabia, while trying to bag all the sand in the desert during Desert Shield, then shifted into high gear to adapt his Russian Language training to interpret information in Arabic during Desert Storm. A crash course in Slavic languages and he was off to Germany during the Bosnia conflict, then back again for Kosovo. He returned home from the last of four foreign tours in September 1999 and was looking forward to his retirement after twenty years service, and a new beginning. A soldier's orders always come from a higher source and he had no choice at the crossroads but to obey when his orders again challenged his best. His father, Grant Hudson, who preceded him in death March 3, 1999 waited to escort him to his new assignment.

Barry abhorred injustice, hate, disrespect, racism and religious intolerance. He always seized the opportunity to stand on the side of the victims of these social evils that uselessly separate people. In his military experience he saw the handy work of these evils, but said, "Military power cannot rid the world of this depravity."

An honor student, Barry is a graduate of Edmond High School, where he was on the tennis team and Barker staff. He is a graduate of the University of Oklahoma and Defense Language Institute in Monterey, California. He was a member of the First Baptist Church of Edmond.

Barry was born March 10, 1955 in Guymon, Oklahoma, the only child of Grant and Geneva Hudson.

Military services will be held at Ft. Gibson National Cemetery, Muskogee, Oklahoma at 9:00 AM February 1, 2000.

Friends and family and those who want to pay respect to this military hero are invited to join his mother in a Celebration of Life memorial service in honor

of MSGT Barry Kent Hudson, on February 5, 2000 at 2:00 PM at Oklahoma Christian Home Community Center, 503 Enz, Edmond, Oklahoma.
 —printed in the *Edmond Sun*, 02/29/2000

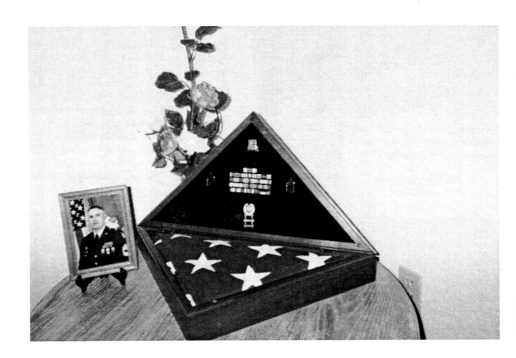

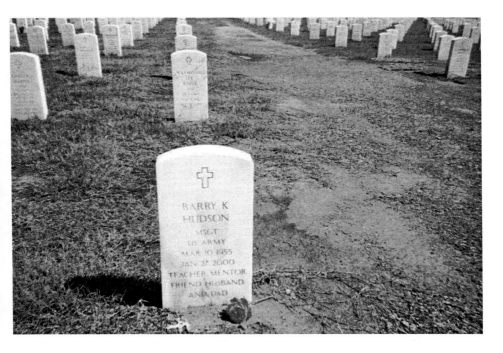

Not our sons, not your sons, not their sons,
soldiers are members of families.
—Women Strike for Peace, 1960

*Geneva Johnston Hudson*

A burial ground for veterans of the War of 1812
and soldiers of the Indian Wars, Fort Gibson cemetery was
established as a National Cemetery in 1861.

The site pictured above is near the grave site of Seaman First
Class James Monroe Johnston Jr.
Who was killed in the Pacific theatre during World War II. The
Seaman is Barry's uncle.

30

JUST AS I AM

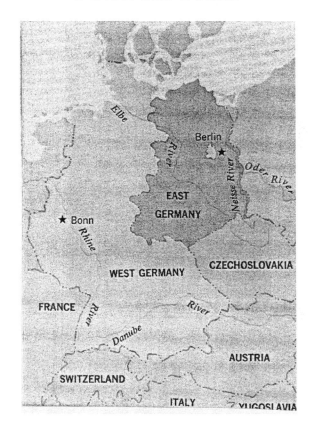

BY

MSGT. BARRY HUDSON

Geneva Johnston Hudson

INTRODUCTION

With all due respect to Bill Mauldin whose Willie and Joe kept us in touch with the front in World War II, Barry found a real life Joe and Willie in Germany during the Cold War era. He weaves this tale of what he came to know about these two left-overs of the Great War, who were on different sides of the conflict. Although Joe and Willie are of a different time and generation Barry in someway identifies with them as though collectively they are himself. One is a victim of circumstances with an unfulfilled dream, but who played the hand dealt him with a zeal that compensated for the dream. The other whose war had a different objective came to understand that "war is hell," while succumbing to a soldier's dedication —MacArthur's "Old Soldiers Never Die; They Just Fade Away."

You will catch a glimpse of the Okie in Germany as Barry vents his frustrations with the "unamerican" way of life on the streets and especially his impatience with European traffic. Subtle humor adds a bit of satire to relieve the technological lingo while a deep interest in the American Civil War creeps in to offer a simile.

While in high school during the student unrest of the Vietnam era, Barry wrote an essay. He and I discussed his thesis — revolutions are led by students. It was his premise that students were encouraged to think, to challenge, and to develop ideas independently of the status quo. The idealistic student discovers the Bill of Rights, and challenges governments to provide these freedoms equally to all. It was easy for a student of the 60s and 70s to be a dissonant when everything he was learning seemed to be far fetched and unrealistic. In light of this idealism the Kent State tragedy was especially painful to that generation. The senseless emotional driven riot and bloodshed of Kent State adds meaning to Barry's dream sequence.

Just As I Am, was written late in Barry's military career. He had seen the senselessness of war, oppression, racism, and intolerance. It had been his duty to be one of the "good guys" trying to bring order out of chaos. The nightmare dream in *That thy blood was shed for me* vividly describes the tyranny and intolerance of which he had seen the aftermath. You will come to recognize the sensitivity of this soldier, and the burden he felt was his, just because he was, who he was — just as I am.

Taking a literature course in college, Barry was frustrated with symbolism, once proclaiming, "Why can't yellow just be a favorite color, instead of having to have a hidden meaning?" I thought of this as I read the dream sequence. The woman had raven hair, blonde hair, and wore a red dress at one time and later black pajamas. This is symbolism, **THE WOMAN IS EVERY WOMAN.**

Barry spent more than ten years in Germany, but there was never much time to sight-see. He shares with the reader a good time with friends on one such

adventure. It is heartening to know of mthe camaraderie among these friends —
men whose common dominator was the uniform they wore—of how they were
into the happiness and heartache of each other. Reading this will give you a
warm fuzzy feeling for our soldiers who sacrifice what we take for granted. You
can feel the loneliness and homesickness.

Perhaps you will be taken aback, or even prompted to ask "What?" when you
read the sentence that seems to have no ending. This is sort of a trademark with
Barry. It is a challenge to himself to create but it is also thrown out as a dare to
anyone who might try to edit the work. This particular harangue is a tongue-in-
cheek commentary on his responsibility for the moral of his soldiers.

*A sentence that wanders and weaves all over the place can be a beautiful
thing*
(A comment by Shelby Foote, Civil War Historian, in a TV interview.)

Notice the comparison between leisure hours for American kids, and those of
Germany. Pick up on his description of family life the American way. Later, I
choked back the tears upon reading the vividly description of his father's
Alzheimer condition.

Jewels of wisdom are scattered throughout the piece. I'll mention only three.
1) *Something has to affect us deeply to change our perspective of the way we
interact with the events that surround us.* 2) *In the background, I can hear the
music of frustration, despair, deceit, and counterfeit salvation. It seems that
songs about peace, love and understanding are not as popular as they used to be.*
3) *Chatter dressed in camouflage screens personal heartbreak or happiness.*

When Barry brought me *Just As I Am*, he asked me to read, and correct
spelling and punctuation. Later he and I had a brief conversation about his thesis.
He talked with a genuine affection for the "Willie" of his story, but a little less
compassionate for "Joe". I did not approach the dream episode with him. I felt it
was too personal for him to speak of because it lay bare his intermost feelings, a
place not open to his mother.

As you read *Just As I Am*, you will come to know the soldier whose love for
life and for his fellowman was deep seated, proving the military evaluations you
read in the preceding pages to be true.

Just as I am...

The TV news covered it all the other day. It was big news from the moment the story broke. Geri, also know as Ginger Spice of the Spice Girls, had left the group. The BBC was at the official announcement. So too were Skynews and Channel 5. CNN sent a crew from its London office. Managers from the group gave a few sound bites. There were some quotes and clips from the remaining girls. The camera framed the tears of a young dark-skinned fan dripping on the black foam head of a thrusting microphone. It seems that Geri/Ginger was her favorite Spice. In the amplified cracking of her lilting English middle-class voice you could just make out the word 'Traumatic."

Traumatic. That's the way most life-changing experiences are described. I suppose it has to be that way. Something has to affect us deeply to change our perspective on the way we interact with the events that surround us. I'm sure traumatic is the one word that Joe and Willie might use to characterize their life-changing experiences of a half-century ago. Like the dark-skinned fan, they were young then. Although, to tell the truth, at that time they were probably four to six years senior. And while four to six years, like a half-century, is just a drop in the bucket in intergalactic time, it means something in the pubescent years. It isn't until you get a little older that four to six years melt away like ice on a hot summer street.

Joe came from Cleveland. He biked the streets of the mistake by the lake, pitching papers and collecting pop bottles. Mom needed the money. It seems Dad didn't care too much for fatherhood and had taken off "somewhere down south" leaving her to fend for herself and the three kids; not the normal picture we get of 1930's and 40's American family values. Somehow, Joe made it through those tough times with both his brain and his innocence intact. That morning, Joe and his mother took the street car across town to visit some relatives. On their way back, Cleveland was about to explode. That's how Joe remembers hearing about Pearl Harbor. Energy rushed through his body and

fired his imagination. America was going to war. This would be the war to end all wars. The world would be safe. He knew it. He felt it in his heart. The people on the streets of Cleveland and streets all across the land knew it and felt it too. Joe was 17. I wonder what his mother knew and felt.

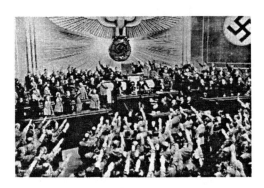

Willie is a little older than Joe, just a year or two. He spent the thirties running and playing football, while iron boots wore down the cobblestone streets of his native Magdeburg. At 17, he was a fit and trim 70 kilos. Politics wasn't in his vocabulary. Sports and girls were much more to his liking. When he was 17, the war was in its first full year. Free France was a memory, the bombs were raining from London and Berlin skies and Hitler had ordered the opening of a new meat-grinding factory — the Russian Front. At 17 and 70 kilos, Willie was meat made to order. The frost was barely on the pumpkin by the time he reached Kiev. His infantry regiment was over a 1000 strong and was still singing on its march toward Moscow. By the time the winter of 1940 set in, their singing had stopped. If he had been at home, his mother still would have been buttoning his coat. I wonder, as he stood stamping his frozen feet against the cold with his empty eyes peering out from his guard post toward the unreachable gates of Moscow, which he missed more, his mother or the coat.

Without one plea...

According to the TV, the most trauma felt by the impending break-up of the Spice Girls will not be suffered in the hearts of their endearing fans but in the pocketbooks of the corporations that use their image to sell products. The Spice Girls are big business. They sell everything from fashions to soft drinks. To the purist from the Rock Age, such crass commercialism of musical art is the highest form of sacrilege. Of course they say this while their toes, protected by the fruit of slave labor, tap to the beat of the greatest hits of the sixties and seventies now featured in the advertisements of carmakers, brewers, dairies and a wide variety of other goods. Some dreams die hard, with others there's no muss, no fuss. We

can all name the groups that have broken up. When they fell apart, we all asked "Why?" Maybe they were like passion without love, all kindling and no coals. While they were together, we were like children frolicking in an endless summer, sailboats coasting on a sweet breeze. When they left us, the skies grew gray and we grew harder, colder, more ready to accept the transitory reality of nature, more likely to watch pots and clocks. As time past, our indifference swelled and we began to expect all promises to be broken.

Joe had a brain and it was his brain that got him into college and out of the first round of the draft. Although his body was trapped on Ohio's Oberlin campus, his heart was at the front. Unfortunately, the news from the front wasn't all that good, The Japanese swept over the Philippines and pushed their advantage toward New Guinea. German U-boats were wreaking havoc in the shipping lanes supplying Europe. The Yanks had hit the beach in North Africa but their advance had stalled in the sands of Kaserene Pass. Everyone still believed we were going to win, but it was going to be a little tougher than expected.

Joe knew he didn't have to go. No draft board would ever accept him. He was nearsighted. So he got his friend, a med student, to steal an eye chart for him. He spent nights memorizing it. Before long, he was ready and when the government announced a new program that would allow him to stay in school another year — sending him to basic training, making him an officer and then sending him back to finish his degree before heading off to war — Joe jumped at the chance. However, another year at Oberlin was unbearable, so he packed his bags and caught a Santa Fe train for the coast and UCLA. On the platform, his mother waved goodbye to her baby.

Shortly after Hitler's failure to sweep the Soviets from Moscow and off the game board, Willie got the break he had been wishing for — his orders transferring him out of the infantry. He was going to be retrained for the Signal Corps. As he made his way through the backwater of the front, Willie could see that Hitler's Field Marshals were preparing for a second round. He had a train to catch in Minsk and 10 days and 500 kilometers to get there. He flagged down a diesel. The driver gripped but relented. A fifth of the journey was down at only the cost of a day, a good pace, which if he could keep, he might get there with a few days to spare. The next day his luck ran out and he wasted two days at a fuel depot in the middle of nowhere before bribing a motorcyclist with two packs of English cigarettes that he had stolen off a dead Soviet officer. The sidecar was freezing, but it was good for another 150 K's. By hook and crook, by boat and boot, he made it to Minsk with 24 glorious hours to spare. A bath, delousing, a new uniform and a bottle of schnapps later, Willie fell asleep on a bench outside the train station.

Willie woke the next morning with a start. He feared he was missing something—his orders. Panicked, he pawed through his pockets. He breathed a long sigh of relief when he found them in his inside breast pocket.

He was right though; he was missing something – his innocence. A steely vacant stare now substituted for the sparkle in his soft blue eyes. His jaunty step was replaced by the heavy thud of an infantryman's boots. In celebration of the loss of his innocence, some general placed a ribbon around his neck. From the ribbon hung an iron cross. The hunk of metal had saved him that night from arrest by the roving patrols of the Provost Marshal. Willie ran his fingers through his brown hair and tried to work the crick out of his neck. He cleaned up in the restroom, grabbed some bread, cheese and a cup of coffee to wash it down and caught the next train bound for Warsaw.

Sometimes things just don't work out like they are planned. About an hour and a half out of Minsk, the train blew up. The Red partisans in the far wood line shook hands in cold jubilation. Willie was blown free of the wreckage. The nudge of the cold steel of a pistol barrel brought him back to consciousness. His blurry eyes made out the black-clad figure of the SS officer. The sight of the death head on his cap caused fear to pound in Willie's Wehrmacht heart. He knew what these guys were all about. He had heard some stories when he was back in Kiev. He had seen weathered peasants hanging from trees. He had smelled the sickening odor of burned flesh that lingered in the air around the barn full of women and children who had been set to the torch. He wanted no part of what he knew was coming. As the SS men and their Belorussian henchmen picked their way through the remains of the train, the officer gave Willie a sick smile and said, "Ah so, the Iron Cross. We could use a good man like you." Despite Willie's protests, the Signal Corps would have to wait for its new soldier; Willie had just been volunteered for the Partisan War. In the distance, black

smoke from a burning village billowed up past onion-shaped domes to kiss a soft blue sky.

Times flies in California, probably because everyday is the same. The Navy had sent the Japanese reeling at Midway while soldiers and marines had begun to hop their way toward the Home Island. Patton had kicked the Nazis out of North Africa and Sicily and the High Command had started operations in Italy. As the troops hit the Normandy beaches, Joe and the other Program boys were busy shoving duffel bags through the aisles of a train heading for Ft. Benning, Georgia. Three hard days and a million card games later, Joe and his buddies reached the Deep South. This was Joe's first trip south of the Ohio River. What he saw through the train window was not the enchanted land romanticized in the 30s' blockbuster _Gone With The Wind._ What he saw was a hard land of sharecropped cotton fields. He saw a dark land where the electric light was only beginning to make its presence felt. He saw a land bountiful in poverty and ignorance. He saw a land divided by hatred, where State-sanctioned oppression encouraged free use of the lynching party's noose.

It was long after midnight when they arrived. The hellish wet air pressed on their shoulders. Some idiot tried to make a crack about it not being the heat but the humidity. Joe wasn't worried too much about the heat or the humidity; it was the mosquitoes that were eating him alive. In the shadows of a small light, Joe could make out a pair of figures. One wore Captain's bars and carried a swagger stick; the other was some kind of Sergeant. The First Sergeant stepped through the light. The ancient platform creaked beneath the tread of his boots. Instinctively, the boys fell into line. The First Sergeant drew a breath and sneered, "Alright, you fucks; Dey tell me y'all got da highest IQ in da whole damn Army. Well, we'll see 'bout dat." At the time, Joe thought he only had 13 weeks of hell to go.

The Captain that Joe had seen at the train station turned out to be the commander of his training company. He had lots of experience in "military" situations. His father, the owner of a Kentucky coal mine, had sent out gun thugs armed with machine guns to fire on striking workers. The Captain had led a raid to burn down the meeting place of the strikers. The fire from the church spread, taking several miner's shanties with it. Although the newspapers neglected to carry the story, Joe overheard the Captain bragging about his involvement in the affair. Of course, the Captain was always bragging about something or another, expecially after he had had a few long pulls from the ever open bottle of whiskey that sat atop his desk, so the truth about what happened in Kentucky is lost in an alcoholic haze.

Given this, it is not surprisng that Joe's Basic Training reflected the Captain's hazy state of mind. It included all of the normal highlights that any survivor of Basic Training can relate. The boys relearned their left from their right. They learned how to hurry up and wait. On occasion after another

drunken tirade from their commander, they made it to the rifle range on time. They also learned how to take a punch in the gut deftly thrown by a Corporal angry over a minor uniform infraction. When their bunks failed to bounce a quarter high enough, they learned how to dig and refill a hole. As they dug, they counted down the weeks that remained until they could once again be free. Some yearned for the return to College life, others coveted the gold bars of a Lieutenant and the chance of revenge on the cruel Corporals, Joe just wanted it to end. With only 2 weeks of Basic remaining, they got the official word. The breakout of the hedgerow country in France was chewing up more men than expected. The War Department needed more troops. Their program was terminated. They were to become infantrymen. After he read the announcement to the formation, the First Sergeant said, "Well, I guess this means you pretty boys are just regular fucks now."

But that thy blood was shed for me…

The young dark-skinned Spice girl fan looked Hindi to me, but then she could have been a Pakistani. Although I'm sure many would consider this a racist statement, I have to admit, to me they all look alike. But then, I can't tell the difference between a Bosnian Serb, Muslim or Croat. Arabs and Jews share many physical characteristics. If you lined up a hundred folks from Ethiopia and Eritrea, I couldn't say from which side of the border they came. I'm glad to say I really don't know how an American is supposed to look. Europeans say we tend to smile a lot. I saw a Budeswehr colonel the other day. I could have sworn I'd seen him before. I think he was a bossman on a drilling rig out in western Oklahoma. Then again, he was down in Texas at a 7/11. He had a cowboy hat and an old blue pickup with a bail of hay in the back. The Budeswehr colonel spoke to me for a while in English. His voice carried no hint of a southwestern twang. Maybe it was a different guy. Sometimes it's hard to tell how far we still have to go until you look at how far we've come.

The Yankee engineers quietly assembled along the bank and began to put the pontoon boats into the river and attach them together with planks. Fredericksburg lay just across the Rappahannock. It was a cold December's morn. The fog hugged tightly to the water. General Lee had detached a brigade of Mississippians under William Barksdale to resist the crossing effort. The residents of Fredericksburg had long since fled due to the threat from the Yankee cannons posted along Stafford Heights. As the fog lifted, Barksdale's sharpshooters, firing from hiding positions in the town's buildings, began to pick off the Yankee engineers. General Burnside ordered his guns to open up on the town. After about an hour the shelling ended and the Yankee engineers went out to try again. But Barksdale's boys were still there and the engineers were driven off again. This time the Yankees tried a different approach. Using the pontoons

as boats, the Yankees floated a couple of regiments across the Rappahannock, which was covered with a thin layer of ice, to the opposite shore. They fought Barksdale's boys house to house and hand to hand. After a couple of hours, Barksdale was forced to withdraw.

The Our isn't that grand of a river when compared to the mighty Ohio. At least, that was Joe's impression when he first saw it. He had seen the Ohio on a trip to visit his aunt in Cincinnati. From his position above the Our he could see a short ridge that ran down to the opposite shoreline, to the right of the ridge and running along it was a farmer's long field, at the end of the field, about 300 yards from the river, there stood a collection of six houses. Joe's squad leader had just finished briefing his troops. He told them that in the morning they and the rest of the company were going to take those six houses. Joe looked back at the river. This time he noticed the ten pillboxes that lined the ridge all the way up to where the houses were located.

Since their arrival in Europe, Joe's 156-man company hadn't seen much. In general they all liked their new company commander, they were met at the docks in England by a long line of Army trucks. The trucks took them to a small camp near some green fields somewhere in central England. While the Battle of the Bulge was raging, Joe's company was finishing training. When they landed on the continent, Joe was hoping they would stop in Paris. The Army trucks didn't stop until they reach Metz. The lads of Joe's company were replacements for losses Patton's III Army had suffered at the Bulge. The crossing of the Our would be the first time they would see combat.

Willie spent seven months fighting in the Partisan War. When he finally managed to get his release, they pinned a badge on his chest to tell everyone where he had been; all Willie wanted to do was to forget. The Signal Corp trained Willie in unit level radio repair, how to run wire and how to set up and operate a unit level communications center. Willie was the top soldier in his training class. He was hoping for an assignment to France. Maybe in Paris or the Normandy coast he could put the nightmares of the Russia experience to rest. It was the summer of '42 and the Nazi war machine was moving in southern Russia. Willie was stoic when he read the orders posted on the bulletin board outside the headquarters office. He was being sent to the Caucasus.

Willie spent only 3 months in northern Soviet Georgia. It was a good three months; he didn't have to fire his rifle once. Then his company commander told them they were going to be sent to a new place, somewhere on the Volga River, somewhere called Stalingrad. Hitler had a fascination with Stalingrad. About the time Willie reached the Causasus, Hitler had begun to refocus the Nazi efforts toward the capture of the city that bore his rival's name. General Frederick Paulus threw the flower of his Sixth Army against the defenses of the city in a desperate frontal assault. When Willie arrived, Paulus had only managed to gain control of half of the city. Subsequently, the successes of the German attacks

were measured in meters. By November, there was only little more than 2 kilometers separating them from the Volga. They would not get there; the Red Army held. On November 19, the Soviets struck the flanks of the German Army group. Within a week, the besieger had become the besieged. Willie held out hope of rescue for about 2 weeks. The orders of the Fuhrer were for the Sixth Army to die in place. On February 1, 1943, Willie crawled out from under the broken slab of reinforced concrete that had been his home for the last 3 weeks and surrendered. Of over 1000 of the regiment that went to Stalingrad, only Willie and 11 others were left.

The boats arrived a little after 0400. A few of them had motors; the rest would have to be rowed. Volunteers from Joe's company helped the engineers quietly assemble them just behind the line of trees that ran along the bank of the river. It was cold that February morn of '45. Joe heard the commander of the engineers give orders to a runner to go back to headquarters to find out where the pontoons were. Patton needed armor to crack the Siegfried line. The pontoons would be needed after the bridgehead was established. An hour later the artillery opened up, first with live rounds then with smoke. The couple of regiments to be used in the attack pushed their boats off the shore at 0530. Recent heavy rains had swollen the Our. Many of the boats were having trouble with the swift current. Nevertheless, all was going well as the attack reached the halfway point. Then the wind began to pick up and the protective smoke screen lifted from the waterline. Sheets of flame erupted from the pillboxes. German artillery shells sent plumes of water high into the sky. Boats splintered and bodies floated downstream. And still they came forward.

The boats hit the shore and the men hurried over the sides. Some never made it out from the waterline. The officers shouted for the men to move forward. Sergeants grabbed men by their collars and dragged them over the little rise at the shoreline. Several of the men in Joe's company remembered their Basic Training and began to dig in. Joe and the others moved forward in rushes, taking turns firing at the flaming slits of the pillboxes…200 yards to the houses, men were falling all around him…100 yards to the houses, the machine gun chatter from six of the pillboxes fell silent and on they came…50 yards, Joe fell hard causing him to swallow a mouth full of dirt…he got up and moved on…he had to, he was the radioman…10 yards, he could see the Germans running from the three houses on the right. Twenty men out of the 156 that started made it to the first house. By the time they took the fifth house, they were down to 12. A German carrying grenades bolted forward from the sixth house. Joe leveled his M1 and fired. That was the first man Joe ever knew for sure that he had killed. The pontoon bridge was completed by 0400 of the next day. The Germans abandoned the sixth house when they saw the tanks begin to cross.

And that thou bidd'st me come to thee,
O lamb of god, I come! I come!...

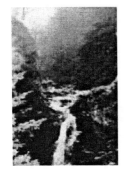

Last year some friends and I piled into a rental car and headed off to a little lake to the southeast of Munich. We were in search of photo ops and apple strudel. AFN was playing something modern on the radio, it might have been the Spice Girls, but whatever it was, I didn't care for it. I pushed in a tape. All of the artists on the tape were either dead or about to be. The clock was at about 11 o'clock daylight saving time. I opened the sun roof. The road to the lake wound through the foothills of the Alps. I hit the curves like I was AJ Foyt, pushing the limits of the German-engineered machine. The Germans passed me like I was standing still. Along the way, we stopped a few times to take some shots with our small one-time-use cameras.

The timeless town of Tegernsee sits on the shores of a deep blue mountain lake with the same name. Across the street from a small marina there stands an old hotel. From the balconies of the upper floor rooms you can look down on multi-colored sails dancing across the water or enjoy a sweet breeze in the kaleidoscope of a setting sun. Romantic. One of my friends was fixing to have to say goodbye to his girl friend. We stood in front of the hotel and all agreed that this would make a perfect setting for a memory that they could share until they were reunited. That's a nice way of saying that each of us were delighting in our own sexual fantasies. My friend broke the spell when he began to worry about costs. "Fuck that," one of the other guys in the group said, not wanting his dream to die, "this place is too good to worry 'bout money." Living vicariously, we crossed the street to find out the price of our separate visions.

The owner of the hotel met us at the registration desk. We shook hands and he discreetly switched to slightly accented English. He said he'd cut my friend a deal; a room with a shower and all the pancakes you could eat for breakfast for only 100 Marks. Pointing to an old black and white picture of two young men standing in front of the hotel, he said, "Americans used to stay mit us

all of the time, when they were still in Munchen." He gave us a brochure and told us to call for reservations. We walked on down the street, sat down in a little outdoor cafe and had some coffee and apple strudel beneath a peaceful sun. It was a high quality day. My friend never went back to the hotel. Things just didn't work out.

Joe spent the next night on the cold floors of an old castle. Unbeknownst to him, in the basement a fifteen year old member of Hitler's Youth stood guard over his panicked mother and baby sister. At dawn, Joe's unit rejoined Patton's race for the Rhine. While the kid hid his rifle, his mother burned his uniform. Their war was over. Shortly after crossing the Rhine, Joe shot and killed his second and last man. The man was old, maybe sixty.

The Allied advance moved swiftly after the crossing of the big river. By early Spring, it had reached southern Germany. Joe's platoon made camp by a slow moving stream about 15 or so miles northeast of Munich. The dandelions were in full bloom and their rich yellow accented the lush carpet of green grass. Butterflies flittered beneath the boughs of the cottonwoods that hugged the creek bed. The sun sat low in a soft pink and deep velvet sky. Its fading brilliance reflected in a gentle mixture of orange and gold that shimmered across the onion-shaped spires atop the nearby village. The men were uneasy. Joe's Platoon Sergeant felt it too. Something to him just didn't smell right. He doubled the guard shifts and told the others to try to get some rest. Aside from mosquito attacks, nothing happened that night. The boys ate a quick breakfast that morning, Orders for them to move north toward Regensburg had crackled over Joe's radio. A little bit later they reached the main road. The map said they needed to go left. A right turn would have taken them somewhere they didn't want to go – Dachau.

Somewhere in a forest of what was then called the Sudetenland and what was about to be called Czechoslovakia again, Joe's radio barked the word. The war in Europe was over. Joe's unit was redeployed to Munich. Although they were ready, the army wasn't ready to send them home quite yet. Something had to be done with the millions of dislocated civilians. Europe was on the move that summer. Everywhere everyone was seeking shelter in the rubble that had once been the most beautiful cities the world had ever known. Everywhere everyone was trying to find their way home. Everywhere everyone was searching for what had been their lives before the war. Everywhere everyone was looking for each other. Joe was sent from Munich to Frankfurt. There he handed out clothes, blankets and K rations to the refugees. There he ran a shower and delousing station. There he waved goodbye as they boarded the trains that would take them finally to what remained of home.

In August 1945, the United States introduced the mushroom cloud to the world. The Great War was over. While everyone else was trying to find their way home, Willie sat in a prison cell somewhere in the Ural Mountains. At first his Soviet captors didn't know what to do with him, except try to starve him to death. When that didn't succeed, they put him to work. They began with odd jobs around the gulag, later they moved him beyond the barbed wire to do some road construction. When he wasn't working or sleeping, he was being re-educated. The collected works of Lenin and Stalin were the standard fare. He had to learn the phrases by heart for to misquote the great men meant a long stay in solitary confinement.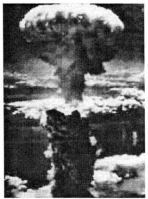

Willie spoke a little Russian, which improved as time went by. He convinced the camp commander that he knew a little something about electricity. This was very important because at that time electricity was only beginning to light the dark nights of the central region of the Soviet Union. Willie was shipped from gulag to gulag to help install and maintain electrical systems. Willie was becoming an important prisoner. Being an important prisoner comes with a price. On the one hand, if you become an important prisoner in the gulag you get more food, while on the other hand, one runs the risk of never being freed. Willie was walking a tightrope.

As the electrical grid spread to Soviet Central Asia, so to did the need for electricians. Willie was taken to dull underdeveloped places with exotic names: Bukhara, Tashkent, and Dushambe. Willie helped bring light to the Pamir and Altai Mountains, cousins of the Himalayas. For many of the people he saw there, he was the first person they had ever seen with blue eyes. He would catch them staring at him even though they knew that to ever look at a gulag work gang could mean sever punishment from the Soviet authorities. From the mountains, Willie was sent to the vastness of Siberia. They worked him in the mines, in the logging camps, on the railroads and hundreds of other places. In the gulag, there was always work, there was also no time. Days, weeks, months and years were but parts of a string without measure. Food, sleep, clothing and work, these were the things that had meaning even when they had no purpose.

In early '46, Joe was reassigned to a dream job. He was to be the driver for a

 bunch of reporters sent by the big newspapers to hunt for Nazis. Daily the reporters would pile in his staff car and they would hit the road to run down leads and witnesses to the whereabouts of some of the greatest criminals in history. When he first took the job, Joe thought this would prove to be the most excitement he would ever have in his life. He thought it would be like a cross between being a spy and Elliot Ness

with the romance of Hemmingway thrown in for good measure. After a couple of weeks he realized his dreams couldn't have been further from the truth. He was only the driver. He was merely someone to take a back seat full of snooty drunks from one pile of rubble to another. Most of the reporters didn't like or trust him. They thought he was either an Army spy or just some dumb kid. While Joe picked his way through the debris of Berlin, Frankfurt, Nuremberg and Munich, the reporters passed the bottle and retold stories of ancient scandals, wives, box scores, girl friends, boxers and whores.

Before the war, Bavaria had been a hotbed of Nazism. Hitler had gotten his start in Munich and all of Europe was still shuddering from the nightmare of the Nuremberg rallies. They were in Nuremberg, staying in the shreds and remnants of an old hotel when one of the younger reporters knocked on Joe's door and told him to get ready. The reporter had a hot tip that a Nazi bigwig was holed up in the Bavarian Alps. Within an hour, they were on the road. Joe was driving the winding, rain-slick roads like a madman. They pulled into the quaint lakeside village of Tegernsee in the late afternoon.

While the reporter went out to look for leads (a euphemism he used whenever he needed a drink), Joe checked into the hotel. The owner was friendly and helped him carry the bags upstairs to the rooms. Joe took the good one, the one with a window that looked out on the lake. Joe felt like reading so he sat down in a big chair by the glass door that led to the balcony where the light in the dim room was a little better. For a while he was just turning pages, then the book sank farther down and lay open across his lap. Joe gazed wistfully past the rain-streaked glass at the wind-swept white caps on the gray lake, but all he saw were pretty girls in sun hats coasting beneath multicolored sails in a kaleidoscopic sunset. A couple of days later the reporter gave up on finding the Nazi. Joe took him back to Munich. When he reported into Army Headquarters, they gave him the word — he was going home.

Just as I am, tho' tossed about...

Concerned that the television trauma caused by the impending breakup of the Spice Girls may have created a negative impact on the moral of the soldiers entrusted to my care, it became incumbent on me to identify, prioritize, and validate intelligence requirements needed to form a comprehensive collection plan and synchronization matrix allowing for the proper tailoring of assets and thus to conduct a dynamic yet informal intelligence-gathering operation leading to the collection and processing of all time-sensitive critical information warranted for the preparation of a situational analysis necessary for the requisite development of a preliminary contingency plan essential for a feasible and expedient redirection of my primary efforts so as to avert any significant diminution in performance levels in the operational tempo due to adverse effects caused by this potential significant emotional event. Initial analysis of raw collection input from a wide variety of sources indicates that unit moral has yet to be affected by the spreading trauma and remains within acceptable parameters. Futhermore, early reports tend to confirm previously held suspicions that the majority of the unit's personnel consider the Spice Girls as an organization of low quality and one that performs repeated vacuum activity. Although analysis inclines towards a continuation of the unit's tendency to hold this belief structure, it is my intent to carry on protracted monitoring operations through the use of relocated multi-source collection platforms deployed in a split-based array so as to ensure sufficient early warning and thus be able to implement the force protection measures necessary to limit any degraduation to mission accomplishment.

The Big Apple had long since shook off its post-war celebration hangover and had returned to its normal pace of hustle and bustle when Joe, unnoticed, stepped off the boat and back into his homeland. After a couple of days of out-processing and a couple of more to see the glittering sites of New York's man-made canyons, Joe boarded a train out of Grand Central Station bound for Cleveland. He was met there with hugs and kisses. At the house, Joe traded his uniform for a pair of slacks and a new blue short-sleeved shirt, which he buttoned to the collar. He sat down in the big chair to try on the new oxfords. They were a little tight. He told his mother he was going to stretch them out with a little walk, but she could see in his eyes that he was already restless. That summer he walked down his old streets, sat on

47

some park benches, took in a couple of ball games and had a few beers with old friends at a corner bar. By August, the shoes were broken in. With suitcase in hand, he waved goodbye to his mother and hopped on another Santa Fe. He was California bound again.

Despite the allure of her golden sun, sandy beaches and swaying palms, California could not keep Joe from gaining his degree. Packing UCLA's sacred document carefully away, he traded the Gold Coast for New York City and Columbia. He made a quick stop in Cleveland before moving on to begin his Master's program. His dream was to be a Professor. If he saw her in the throngs of thousands that crowded Grand Central on the day of his arrival, he never mentioned it to her. She was wearing a white hat with a black bow, black skirt, white blouse, black high heels and new nylons. She was fresh off the train from Connecticut. If she was a little lost or felt a little overwhelmed, she hid it well behind her veil of Yankee confidence. Joyce was a rich man's daughter.

The electric sparkle of Times Square had nothing on the gleaming beams that came from her sweet brown eyes. For a man that had faced the chatter of machine-guns, Joe was shy when it came to girls. Although it took him a second to fall in love with her, it took him a month to talk to her and a second month after that to ask her out. They took in New York on a purse string, for that was about all that Joe's billfold could manage. By Spring, she felt the same way about him as he did about her. It was time to get married and so in August 1948, they did.

They found a five-floor walk-in flat near Columbia. Joyce gave the place color and warmth. Despite a tight budget, she was never happier. Neither wanted to accept the strings that came with her Daddy's money. Joe worked odd jobs between classes. They managed. Columbia granted Joe his Master's that following Spring. Joyce's mother decided that Joyce needed broadening, so she offered the young couple a trip to Europe. Joe didn't put up too much of a struggle; he wanted some time off before beginning his Doctoral program. He accepted the proposal with only one condition — they would not go to Germany. He had seen all of the Fatherland he wanted. When they landed in France, Joyce whispered softly into Joe's ear that she was pregnant. Ready or not, it was time to have children.

In 1947, following growing tensions between the two superpowers, the United States announced the Truman Doctrine. Along with this policy of confinement came the Marshall Plan, which spent massive amounts of money to rebuild Western Europe to keep a potential communist takeover at bay. America was becoming as neurotic about Communism as Stalin was about everybody in general. Stalin retaliated against the American initiatives by blockading Berlin. Truman ordered the US Air Force to carry supplies into the beleaguered city. From Wiesbaden, Frankfurt, and dozens of other airfields hundreds of planes carried tons of life-sustaining food and medicine to the Berliners. Soviet-

American relations continued to deteriorate. In 1949, the Soviets exploded the bomb. As the two nations began to settle for a protracted Cold War, Korea became the first fire that would prove the lie in the term given to the Communist/Non-Communist conflict. In 1953, Stalin died, but the Cold War went on and on.

Of course, Willie didn't hear the mournful tones on Soviet radio announcing Stalin's death. He learned about it the hard way. First, he was beaten and thrown into solitary confinement for quoting Comrade Stalin during a re-education session. After he got out of solitary, he noticed the former god's pictures had been removed. The picture of a bald man with chubby cheeks affectionately called Nikita by the guards had taken its place. The new buzz phrase around the camp dealt with the elimination of the Cult of Personality. Willie found out he could learn a lot about the outside world by the way the guards acted. When the guards ceased using phrases about American imperialistic aggression against the people of Korea, Willie knew that the fighting there had come to some kind of end. When he was no longer allowed to use quotations from Chairman Mao, he knew that there was a rift in Sino-Soviet relations. When the guards mixed more dirt and fur in his gruel than usual, he knew that Soviet agriculture had failed to meet its quotas in grain production. When terms like Peaceful Coexistence came to vogue, he knew that the bald-headed guy was searching for better relations with the West.

They stayed in France a little longer than Joe had imagined they would — 7 months more. Joyce was past the "getting big" period and was well into the "beached whale" part of her pregnancy. Joe was getting worried even if Joyce's mother was not. He didn't have time to play at being an American in Paris; he had a family to support. He scanned the classified of the English language newspapers. It didn't take too long before he found a job; however, there was a catch. The job was in Germany selling insurance and financial planning to the thousands of young GI's now showing up there for the Cold War. Joe and Joyce talked and he decided to take the job. They would only stay a couple of years. Then they would go home and he could go back to doing what he really wanted to do — teach college. A month after they moved in, Joyce gave birth to their son at the Air Force Hospital in Wiesbaden, Germany.

With many a conflict, many a doubt...

My headquarters building is filled with thin false walls, that enclose offices with high ceilings and maze-like hallways. As I wonder through the crooked corridors, I can feel the buzz of hyperactivity. Promises of a better tomorrow issued by secular and religious authorities are the subjects of passing conversations around the copy machine. Chatter dressed in camouflage screens personal heartbreak or happiness. People act out ancient superstitions while

electrons hustle vital messages and traffic gossip through conduits both old and new. In the background, I can hear the music of frustration, despair, deceit, and counterfeit salvation. It seems that songs about peace, love and understanding are not as popular as they used to be. For such a small building, it is easy for one to become lost. Some people ask me for directions. Most choose to find their own path. I suppose, in the long run, it really doesn't matter how they get there as long as they get what they need.

The 50s came fast and business was good. Joe was making money hand over fist. Joe's smooth and easy sales pitch gave him good contacts among the base leadership. It didn't hurt that he was a veteran. He sold most of the Colonels a policy or an annuity. They trusted him and in turn they placed him in touch with the endless stream of new Captains and Majors arriving almost daily in Wiesbaden. Joe knew that Captains and Majors were family men with money and family men with money were always interested in prospects of financial security. With good prospects like that, Joe kept his appointment book full up to 9 or 10 o'clock most weeknights. Not that weekends were much different. Saturdays were taken up with paperwork and dozens of honey-do chores that Joyce had stockpiled for him during the week. Sundays were anything but a days of rest. Dressed in their best, the family rushed off to the Chapel where Joe exchanged pleasantries and hearty handshakes with clients, both current and future. After services and a big Sunday dinner, Joe had to scamper to make an afternoon sales call or teach his financial seminar at the Officers' Club.

Joe never really wondered if Joyce was happy. He assumed she was or she certainly would have told him. With all the money he was making, he could buy her anything she wanted. Surely she couldn't want for attention, she had all that anyone could ever want from little Ronnie alone. And if that weren't enough; well, there was the new one on the way. Besides, she had her bridge club, her charity work and all of the functions at the Officers' Club. After all, she was an educated, rich American girl enjoying an extended European vacation, what more could she want? If anyone was being shortchanged, Joe feared it was Ronnie. Gone were his days as a bouncing baby. Gone were his days of toddling about their apartment. He would be starting school soon. With his playmates always moving, Joyce told Joe she was afraid Ronnie would never learn how to develop strong friendships. Joe was worried about the cultural problems. Ronnie was an American kid growing up in a foreign land. This was a land where children didn't play outside, where there were no nearby creeks to explore. This was a land without places to play army or have dirt clod wars, where there weren't any kids to get up a game like Kick the Can or Red Rover. And the worst thing of all, at least that was what Joe thought, it was a land without Baseball. Joe was concerned that Ronnie wouldn't be able to relate to the kids when they went back, which would be soon — right after the new baby came. Joe promised himself he would spend more time with the boy, help him with the things Joe

knew he needed to know, but the demands of making a living stole so many precious moments that he could only replace his absence with presents. And so Joe's life, like the nearby Rhine, flowed by swift and certain with each day being the same just different.

Sometime in the Spring of 1955, Willie and several other survivors of Stalingrad were herded into freight cars. Willie believed that they were being shuffled to another camp. The train took them to Moscow, where they were given a good meal and fresh clothing. From there, they rode in a sealed train that carried them all the way to Berlin. It was the first time he had ever been in that city, so it was not surprising that he didn't recognize any of its landmarks. In the dead of night, Willie and the handful of men that were with him crossed over a bridge into the Western sector. They were the last of 6000 German survivors of Stalingrad, the majority of which had been released shortly after Stalin's death. A day or two later, after being poked and prodded by a dozen or so doctors, Willie was put on a bus and sent back across the East German frontier to Frankfurt. The closest Willie came to his hometown of Magdeburg and what remained of his family was the exit sign on the East German Autobahn. The Bonn government promoted Willie to Sergeant in the Budeswehr and then gave him a pension and allowed him some extra pay if he would remain in the reserves. When Willie left for the Russian front he was a fit and trim 70 kilos, he returned broken, weighing only 48. Although therapy would give him back the use of his left leg, the athletic spring in his step was replaced by a permanent limp. The goverment found him an apartment near the small German city of Friedberg, not far to the north of Frankfurt. At first, Willie rarely left his apartment except for groceries or to go to an appointment. He would catch a game on the radio, but mostly he slept or sat silently in the pale yellow glow of his small table lamp. He was now a prisoner of horror itself. After a couple of years Willie began to venture out on short walks. He loved the morning calm. It was a good thing that he was used to solitude for few people ever talked to him. In fact, most people would look away rather than catch his eye. There are no secrets in small, crowded towns. Many knew who he was and where he had been. But most just preferred to forget men like Willie and to forget that it, the war, had ever happened. They were building a new life, a new country and remnants of the past, like Willie, were best ignored or left behind. It was easier that way.

There was a buzz in town on that glorious morning in 1958 and Willie heard it the minute he stepped from his apartment to enjoy the peaceful warmth of Indian summer. He hurried down the three blocks to the main street to see what was happening, but what he saw shocked him so that it left him with bugged-out eyes and a mouth gapping wide. His mind had never conceived of such a sight. There were hundreds of them — teenage girls from all over Germany — all

waving teddy bears and American flags and all of them were shrieking and screaming, "He's coming! He's coming!" He searched in vain to find someone to tell him who was coming. The only thing he received in response to his questioning was the look that made him feel as if he were from another planet. All he could figure out was that an important American, maybe the President, was coming, but he was at a loss to understand why Eisenhower would be met by teenage girls with teddy bears. After pushing his way through the throng for blocks, he finally met someone that could explain what was going on if he could only muster up enough English. Willie had seen American soldiers many times on the streets of Friedberg. His walk even took him by their base. Normally, his approach with them was to give them a wide berth. Partly, he avoided them, although he will never admit it, was because they scared him a little, especially the Black ones. Partly, it was the language barrier. Willie knew only a dozen or so English words and the Americans seemed to insist on speaking only English. Willie was surprised to see the Black soldier he was approaching was a senior Non-commissioned Officer, or at least that was what he thought all those stripes meant. "Please, was ist das?" Willie asked, his arms and eyes indicating the helplessness of his confusion. The Black man's answer only left him more puzzled than before. "Elvis," the sergeant said smiling.

Tom had come into the Army in 1940. In his eyes, it was a good job and a great way to get out of Mississippi. He had spent the big war on dozens of loading docks that had been strung out across the Pacific. He didn't see a need for a ticket back to Mississippi at war's end, so he signed up for another hitch. During the Korean Conflict Harry Truman integrated the services, Tom thought there was a chance for promotion in the Tank Corps and applied for a transfer. He entered Korea as a gunner on a Sherman tank, before he left he was the Platoon Sergeant. Tom left Korea for Ft. Hood where he received another promotion to Company First Sergeant. Tom loved being the top soldier. The men liked him too. He was tough, honest and fair. He had only been in Germany for a couple of months when he met Willie. The unit he was assigned to didn't have any First Sergeant slots open when he arrived, so he was made the Battalion Operations Sergeant. The job consisted only of paperwork and phone calls. There were no troops to lead. Needless to say, Tom hated it. He looked at the bewildered German standing in front of him and was filled with empathy. "Come on, man," he said taking the man by the sleeve, "let's get some coffee and I'll try to explain." Willie only understood the word 'coffee', but it didn't matter, he had found something he hadn't had in a long time, he had found a friend.

Joe was dead tired when he reached the Captain's door. Despair, dissatisfaction, distress and disgust had combined with dormancy, drudgery to create a depthless dark hole that drained all the dynamism from his essence and left him directionless and adrift amid the doldrums of his doctrinaire existence.

The drab and dreary skies of December weren't helping with his depression. The decade was closing and he couldn't see any change in the distance. It had been a decade that should have never happened. All of his dreams had ended in disappointment. He should have been teaching or perhaps even a dean at Dartmouth or another university located anywhere between Delaware and the Dakotas. He should have been taking Joyce out dining and dancing. He should have been taking the boys, Ronnie, practically ten, and Danny, the baby that was already five, to the ballgame, sitting down front behind the dugout. He should have been doing anything but what he was doing — knocking on some Captain's door desperate to make another deal. Joe locked away his doubts and dismay behind the veneer of his smile and knocked on the door again. A house in a state of chaos greeted him. He offered to come back at a better time, but the Captain would have none of it. He apologized for the swirling insanity, making excuses about the way teenage girls had to have everything perfect and he promised that things would settle down just as soon as the boy arrived to take his stepdaughter to the party. Joe lied when he said he understood. Although her makeup made her look older, Joe could tell she was not yet fifteen. Joe knew he would never allow a girl so young, chaperoned or not, to go off in the middle of winter over an hour away up near Friedberg to a party for someone's promotion to Sergeant. Maybe times were changing, but he wasn't. Joe was on his second cup of coffee before the boy came and he and the Captain finally got down to business. Two hours and a third cup later, he had a handshake and some signed paperwork. It wasn't too late. If he hurried and didn't get lost in the dizzying maze of detours caused by all the road construction, he might be able to make it home before his family drifted off to sleep.

Fightings within and fears without...

It was just the other night. I was in one of those dead sleeps, when I heard her sobs coming from the dark corner that I always try to avoid. In vain, I fought for my sleep, but the sobs grew stronger and there was no escaping my duty. I pushed through the sticky webs that hide in the shimmering haze of slumber ascending to some level of consciousness where I felt I had never been before, but was unsure if it wasn't my usual reality. I lifted myself from the bed and made my way toward those wretched sounds of anguish. I could see her silhouetted by the milky moonlight that filtered through the window shades of the murky corner. She was lying on her side in a fetal ball. Her long black hair, matted by tears, stuck to her face covering her dark-skin cheeks. I felt my hand begin to reach out to touch her shoulder. I was filled with the need to hold her and give her comfort, but fear restrained the desire. Compassion, today, is so easily mistaken for perversion. Instead, I pulled the cord of her table light. Its yellow glow replaced the silver glimmer that outlined the darkness. On her

nightstand, I saw a white book. Letting my curiosity get the better of me, I picked up. The gold lettering on the cover claimed to chronicle the past, but I knew better. I opened the book and began to read aloud. I heard my voice jingle-jangle in the early morning air and as she began to follow her crying commenced to still. Like all you would want in a good fairy tale, the first words ran, "Once upon a time," but it ended in a mystery leaving you with only a little of what you need. When I finished, she looked at me and her wide eyes whispered, "It's time to go."

Mosquito wings beat on breathless air as we lift through the veils of our obscurity and shake off our shackles to time, only to stand at the corner of 14th and Existence, where hopes and dreams are boxed and warehoused and memories, both light and dark, are just simple melodies that fill the air. I fumble for a cigarette, while I check the old place out. Down the block, they've got the hoses on full against the black fire, but the kids playing whiffle ball in the street don't even seem to notice, they're too busy chasing the fly balls that arc across the red-tint sky or popping tar bubbles with their toes.

She lets go of my hand. Her blonde hair peaks from beneath the hood of her white pullover, her red dress bounces as she chases the black limousine. Cold shudders force my eyes closed and when I reopen them she is moving upstream in the trafficless street. Her black pajamas shimmer with heat. Two long-hair hippie-likes emerge from an underground VW van as the fast mover banks for its attack run. End over end the cans flip before the world turns orange. Naked, she dawns on the far side of the street, her arms outstretched Christ-like, and from them her charred flesh hangs and tosses gently in the jet's wake. The hippies light another joint as she reappears. She removes her beads and tie-dyed T-shirt and pulls her beau tight to her breasts, while musk, patchouli and a touch of cinnamon linger in love's lost breeze. Twin guitars announce the true aim of the National Guard. Like Michelangelo's *Madonna*, she kneels behind the corpse. Her face, frozen pale, only asks "Why?" The landscape blurs and she fades with it. My lungs heave heavily as I rush to find her in the gathering gloom. Panic fills me as I race through the creek bed and scramble up the red sandstone cliff. The dusty red clay stains my white socks. I burst from the scrub oak tree line. But, I am too late. Her shriveled fingers now point with empty gestures. Helpless, I return to the ledge. Hopeless, I jump, plunging back into time's abyss. But she remains, snared in the stillness of that soon forgotten field, clutched tight in her Albanian sister's embrace.

The alarm clock rings and I have returned to this past. Shrugging off the morning pain, I kicked away the covers and cursed the busy day ahead. After my morning rituals, I locked the door behind me and made for my truck. Gray skies and Heidelberg and its Den of Vipers were all that were on my horizon.

Joe snapped the suitcase shut, stepped back from the bed, gave a short sigh and wished that this day had never come. Lost, he examined the dark spot on the wall that betrayed the faded paint. Only yesterday that weird, psychedelic 'Nixon's the One' poster was taped up over that spot. Now it was packed away, like the rest of its owner's things. A short two weeks had passed since the arrival of the special letter for Ronnie. Joe knew what it was the moment he saw it in the mailbox. "My God, my god, not my baby!" Joyce had cried as she collapsed on the kitchen floor. Joe just played the stoic, denying emotion and everything else including his bloody puke spewed across the shiny white porcelain of the toilet bowl. Instead he told Ronnie he was proud of him. He told him to be a good soldier. He told him it was an honor to be called to defend his country. He told him some funny War Stories. He didn't tell him about the hot blood and brains that splattered across his face during the assult across the Our. He didn't' tell him of how the remains of German soldiers were churned into mud by the tank's tracks as they continued their advance the next morning. He didn't tell him of the shakes and cold sweats that came when his memory dam broke and his sleep was flooded with the screams and gore of his war. He didn't tell him of the lost afternoon he spent browsing brochures in a travel office seeking flight schedules to Sweden and train time to Switzerland. If Joe told Ronnie he loved him, he couldn't remember it now as he faced the dark spot on Ronnie's barren wall. Voices from outside told him the family was already in the car and they were ready to go, as if, as Joe could attest, anyone could ever really be ready for what was ahead for Ronnie. Joe lifted the suitcase from the bed and made his way from the room, while in his wake dust particles danced on yellow sunbeams that filtered through the solitary window. It was the first day of the last August of the 60s.

Ronnie was a good boy, President of his class, Chairman of the Wiesbaden branch of Young Republicans. Ronnie did math problems to relax. Ronnie looked sharp in his button-down collar shirt, slacks and wing-tipped oxford shoes. Ronnie only used a little of his mom's styling gel to get his hair to stay flipped back off his forehead. He parted it on the right and the barber kept it off his ears and tapered in the back every two weeks. Lucy, Ronnie's steady since 9th grade, liked it that way, or that's what he told himself anyway. Ronnie was almost proud of his virginity. Even on a military base, Ronnie was square.

Danny was different. Danny was cool. Danny's hair was getting good in the back. Danny bought albums for the long version. He stacked Steppenwolf and Rolling Stones on his stereo and cranked up the volume as loud as it would go until Joe came home and made him turn it down. Posters of the Beatles and Abbie Hoffman decorated Danny's walls. The poetry of Dylan and Kahlil Gibran rolled as easily off his tongue as the political polemics of Stokely Carmichael, Jerry Rubin and Karl Marx. Danny lost his virginity in his imagination and to his image long before his first kiss. Aside from these minor differences, Ronnie and Danny were a lot alike. Joe couldn't understand either one of them. Danny hugged Ronnie goodbye at the airport and flashed him the peace sign as Ronnie disappeared down the jetway.

For the jet-lagged Ronnie, New York's Kennedy Airport was a blur. Somehow he managed to find the shuttle to La Guardia, from where he was to catch his next flight to Cleveland. He was to spend a few days with Grandma before going back to New York for his induction on August 13th. The shuttle bus stunk from the vomit of the wino sprawled across the back seat, old cigar butts, body odor and years of neglect. Ronnie brushed unidentifiable foodstuff from an empty bench and took a window seat. The bus jerked away from the curb. Ronnie gazed with glazed and fading eyes through the grimy window at the New World. In the nineteen years of his life, Ronnie had spent exactly four months in the nation that he was now to defend and yet it still felt like home to him. As they passed the Shea Stadium exit, two Met fans in the front of the bus debated their team's chances of catching the Chicago Cubs now that the dog days of August were upon them. The Yankee fan across from them looked up from his paper and just said, "Fuck da Mets!" Behind him a couple of hippies chatted about some big concert that was to take place somewhere upstate in the middle of the month. Three days of love and peace, they said and best of all it was free. While New York's scenes weaved its abstract pattern before his window, Ronnie wondered what all the fuss was about. What more on earth could those whining hippies want anyway? Peace? Aside from the stinking bus he was riding, this was a grand land, well worth fighting for against the wretched Communist. Didn't they know that if Vietnam fell then the rest of southern Asia would soon follow? Didn't they realize that the peril would spread to our friends in Australia, cross the Pacific and infect South America before crossing to the US's backdoor in Mexico? Peace?!!! Would that be the word they used when the commissar carried away their mother to slave on some unproductive collective farm? Peace, indeed! They had to be stopped, his debate voice rose in crescendo, crushed now and then the world could experience the benefits of the free market...he felt a tug at his leg and heard the gruff voice of the driver say,

"Get up, what's-a-matder here, youz fucking drunk, get up, youz here." Ronnie's plane to Cleveland left just a little late. Below him, as he slumbered, boiled the borderless, green landscape of America in August.

It felt like rain. At least that is what the pain in Willie's back told him. The pain also told him that it isn't supposed to rain on a well-ordered country in mid-August. He ran his rough hand across his face as he tried to focus on the clock on the nightstand. It read four something, much too early to get up for a well-ordered life. He stood, stretched and made his way to the basin to wash up. As the dull razor scraped across his stubble, he remembered why he had to get up so early — orders. Something was up in the East and his reserve unit had been activated. Everyone was to report at six. Sitting around the armory made Willie feel a little uncomfortable, but then it could have been that his uniform was beginning to be a little tight. Everyone in the room knew what was happening in Berlin. It was beaming in live and in black and white on the TV in the corner, but it wasn't official until their Captain read them the 'announcement'. "Today, the 13th of August, 1961," he began, "the German Democratic Republic has proclaimed the cessation of all traffic between the eastern and western sectors of Germany." Some of the men shouted, others cursed and vowed revenge, Willie just rested his head against the wall. Maybe, he thought, the sixties weren't going to be so well-ordered after all.

After the shock wore off, some of the boys started cooking sausages; others began brewing a new pot of coffee. It wouldn't do to start a new war without a good breakfast. Willie's Sergeant came over to him and whispered in his ear that the Captain wanted to speak with him. Old fears shot through his mind. Would they put him in prison or would they simply shoot him for having been in the Soviet Union, prisoner or not? He was shaking as he knocked on the Captain's door. Willie entered on command, saluted and stood at attention. The Captain smiled, stood and loosened his belt. Putting his hand on Willie's shoulder, he said that he understood from the Sergeant that Willie spoke a little Russian. Willie was professionally loud in his affirmative answer. He figured that if they were going to shoot him then he might as well go out like a soldier. The Captain was taken aback by the sharpness of Willie's answer. He lifted his shirt and rubbed the red marks the belt had cut into his belly. "Willie," he began again, "do you know anything about radios?"

YOU ARE LEAVING
THE AMERICAN SECTOR
ВЫ ВЫЕЗЖАЕТЕ ИЗ
АМЕРИКАНСКОГО СЕКТОРА
VOUS SORTEZ
DU SECTEUR AMÉRICAIN
SIE VERLASSEN DEN AMERIKANISCHEN SEKTOR

By 1970, Willie was a legend even though he was virtually unknown. To his co-workers he was a wizard, but to his supervisors he was often a pain in the ass. No one in the German Signals Intelligence community knew more about the Group of Soviet Forces Germany than Willie. He had worked at every border site in the BundesRepublik. He had been instrumental in the modernization of the BundesWehr's listening post in Berlin. In a field where information was power, Willie's hand was filled with aces.

Willie's problem was in dissemination. The years in the camps and beneath the earphones had destroyed Willie's native German language. He now spoke a mixture of German and Russian, freely substituting words from both languages that to anyone but his fellow translators was just a jumbled unintelligible mess. Many of Willie's officers throught he was holding out on them or was simply arrogant. Others thought Willie was a nut. All of them were glad that Willie's 30 years were up. On a sunny May day at a remote site somewhere near Helmstedt, they pinned a medal on Willie's chest, handed him a commission to Captain in the reserves, said thank you and goodbye. That afternoon, Willie took the train back to the only home he had left, Friedberg. Old before his time, Willie spent his afternoons playing cards with other retired soldiers. His pension was pretty good and from the money he saved by living in a small apartment he bought a new Mercedes, replacing it every three years like clockwork. Some evenings he went down to the local whorehouse where Roxanne, the black girl from Nigeria, worked. She only asked one question and didn't mind if he spent his 30 minutes setting in her chair smiling at her. If you asked him, he would only say that his life was well-ordered.

The water in the rice paddy was warm. Ronnie was way out west in Indian Country, where the jungle knew no borders. The chatter of Charlie's machine gun had his squad pinned down behind the paddy's berm. Ronnie had been in tighter spots, but for the moment he couldn't remember when. So far, he'd been lucky; his only wound coming from VD he'd picked up from the whore he'd visited while on R&R in Saigon.

It was the 4th of May 1970 and he was almost half way home and he wanted to keep it that way. He wished that the Lieutenant would hurry up and call for the jets so that he and the other boys could "dedemao-the-fuck out of this shithole." Surely, the idiot could see that there must be at least a company of VC in that treeline. It was a shame that Charlie's sniper had nipped the Platoon Sergeant a couple of hours ago when they were back in that Ville. Sarge, a three-time loser in Nam, was a dick, but he was the only one in the outfit that really knew any fucking thing about tactics. "Lucky bastard," Ronnie thought, "that leg wound meant he had a ticket on the freedom bird home." It was hot and Ronnie wanted a beer. As Charlie's rounds hit the berm with a thud, Ronnie rolled over on his back and gazed into the empty sky. Movement by the VC toward their left

flank had drawn Ronnie's attention. As a result, he missed his favorite aerial show — jets banking for the attack The first jet's rockets landed a little short. The blast knocked Ronnie's helmet off his head ten feet back into the paddy. The next one's fire was on target and they finished off the treeline with a couple of napalm runs. A couple of the boys cheered the orange flames burning hot a couple of hundred meters to their front. "I guess Charlie's char-broiled now," the new guy lying next to Ronnie said with glee. "Yeah, right," Ronnie said as he stood to retrieve his helmet from the murky waters, "Like the son of a bitch was even there."

It only took a couple of hours for the echoes of the gunshots at Kent State to reach Germany. It took a couple of days for the echoes from the explosion of the rice paddy's mine to get there. They came with the shutting of the official car doors. They came on the scraping of the shiny black shoes on the walkway. They came with brilliant brass sparkling in the sunshine. They came with sharp creases and clean fingernails. They came with Captain's bars and Sergeant's stripes. They came with steeled expressions and unsteady hands. They came with a knock at the door. He wasn't dead. Joe could hold to that as a blessing. It took a couple of weeks to cut through the paper work and misinformation to find out to which stateside hospital Ronnie was being sent. Neither he nor Joyce slept on the flight over the pole to Los Angeles. Later, Joe would remember that they hardly said a word to one another. But then again, it had been like that for awhile. They shared the same blank expression as the doctor in cold clinical terms described the loss of Ronnie's right leg and the operation that might save his left. The doctor said Ronnie had sustained some internal injuries from which he should recover nicely. As an afterthought, he told them Ronnie had lost a testicle, but that he should be able to function normally. Disconnected, they walked down the ward's hallway past the two old veterans playing gin rummy and made a left to enter Ronnie's room. They hugged. They chatted. They smiled. They lied with bright faces until the nurse came to chase them off. It was time for his shot. She eased the needle into his arm. Seconds later, a painless Ronnie drifted away. Joyce took an apartment in LA. Joe packed his hope and denial on top of his clothes and caught a flight back to Germany.

O Lamb of god I come! I come!...

It's ten o'clock on a German-May morning and my truck's heater is on high. Heidelberg is in my rearview mirror and the gray skies hanging low over the autobahn ahead are trying to figure out whether the mist should be heavy enough for me to use the windshield wipers. I punch 'play' on the CD player in hopes that the dead guy's voice will ease my headache. I rub my temples and wonder why pain has to be the most significant thing to come out of a three-hour meeting with the Vipers of Corps Headquarters. I ease my pickup's speed up to 79.

Although my big V8 engine begs to run with Mercedes and BMW's my old three-speed transmission thinks 79 is divine. Who am I to argue with technology? Besides, at 79 I can do the autobahn two-step, which is just like the dance, two steps on the left (dive left into the tiny hole in the traffic and then punch it for all you're worth around the slow Czech Republic truck), and one step to the right (dive back into the right lane to avoid the rocket coming up your ass at 3000 mph). I suppose the autobahn two-step would be a lot more fun if you could dance and listen only to Country music. Normally, it takes a little over an hour for me to cover the distance between Heidelberg and Wiesbaden, but when you are on the road with a zillion cars that always seem to stop for no apparent reason, normal more resembles chaos. If all goes well it will be a little after eleven when I get back. That means there will be time for a working lunch

before part II of Day from Hell begins. Day from Hell, that's a good name for it. Heidelberg for breakfast, chicken Vienna sausages and a mountain of paperwork for lunch, a mandatory class from some old guy for a late afternoon snack and dinner with the German partnership unit adds up to way too much on the plate for a semi-introvert like me, let alone for a Friday.

Brake lights. The pace of the world slows to the pedestrian, then crawls, before stopping altogether. The dead guy on the CD tells me that whatever gets you through the night is all right. "Is he nuts or what?" I scream with frustration mounting, "It's not about what will get you through the gooddamn night, It's about what will get you through the fucking traffic." Brunhilde, the perfect blonde goddess in the car to my right front, doesn't hear me. Her images causes my sexuality to explode through my fingertips like the bad fireworks finale on the Fourth of July, a big band of fantasy that bursts across the emptiness before you go home unsatisfied. She sits imperturbable, almost sedate, facing traffic's Gotterdammerung. In her white Mercedes sports car, which is both her shield and sword she defends Siegfried's funeral pyre burning in the twilight of the age of gods against the heralds, who seek to proclaim the dawn of the age of love. The dyke, in the car in front of me, glances her way. She flips her dark orange and deep purple hair back, wrinkles her nose ring and sneers. "Fucking straights!" her body language shrieks, but down deep, you know, she wants him too. The dead guy's CD ends and I change to Cajun to try to lighten the mood. Behind me to the right, the Italian guy's mood is anything but light. He is out of the car. His cellphone is glued to his ear. He is a modern Caesar in his blue suit,

white shirt with its skinny yellow tie. He wears his hair brushed up at the widow's peak. He is the height of fashion and he makes his statement by bringing his fist down hard on his car roof. His blue suit shakes with fury, but his white shirt just looks cool against his dark, Mediterranean skin. Brunhilde's head turns for an instant so she can check him out in the rearview mirror. The goddess's icy grip on the steering wheel melts, slightly freeing her finger, which she taps slowly on the wheel, as she gives his butt a second look. The dyke just pretends not to notice. I just shake my head and laugh. Siegfried's funeral must be over, because we are moving again. The Mercedes, Caesar and the dyke disappear as their warp engines engage. Overhead, if you look really hard, you can see a little patch of blue.

It's late afternoon and the coffee isn't working anymore. The last thing I want to do is sit in this conference room and listen to some old guy drone on and on about the Great War and how rough it was back in the Depression. To top it off, the whole show is starting late. My knees are on fire and my back feels like death warmed over. I get up to seek out some aspirin and a Diet Coke, hoping that movement will quiet some of the pain, yet knowing that such thoughts are but vain dreams. I return a few moments later only half-successful. Caffeine will have to suffice. I am just in time. He is a small man, who keeps his thin hair short and his brown eyes hidden behind thick gold-rimmed glasses. He introduces himself, but I don't catch his name for this dimension has dissolved and all that I see is my father. Imprisoned by his mind, he stands before me, but my hands can not reach out for him, for he exists in that place where time and space, are no longer bound by reference, swirling in a downward spiral that leads to non-existence. The Universe returns slightly out of phase. I try to adjust myself in the chair, counting on that to bring things into focus…it doesn't. The man tells his story, but his voice sounds more like echoes so I only catch bits and pieces: Something about the depression…Something about Cleveland, Pearl Harbor and the draft…Something about the South…Something about some unknown battle over some river…Something about peace, lakes, kids and living in Germany. I fill in the parts I miss from memory or imagination. He tells the group before him about how his ex-wife died in California. With some pride, he talks about the son that is an executive in a computer company. Aside from saying he has had some trouble, the man doesn't really mention much about the other son. Now he is talking about his Fulda-born German girl friend and leading sex seminars where couples sit around naked and explore their feelings. I do a triple-take, because what I thought I heard is completely impossible. My eyes flash at the hard-core Christian sitting across from me. He is just nodding his head like he is in church. I chalk it up to another glitch in the Universe. He winds up his talk by saying we should be passionate about our compassion. On his way out, he stops to shake my hand and thanks me for listening. He departs, leaving me with a Universe that may be beyond repair.

Despite assurance to the contrary, only the Detachment Commander and his First Sergeant will attend the German Partnership event scheduled for this evening. This means that even if I wanted to skip out (which I do, because, one, being responsible, I feel the need for fixing the broken Universe, and two, I'm tired), I can't. So now I'm stuck trying to use this worthless strip map in an attempt to find some hole-in-the-wall town in the middle-of-nowhere, where there is supposed to be a sign that will point me in the direction of the final destination of what seems to be an endless journey. Everything was going fine until I mistakenly missed the fork in the road. Five turn-arounds later and just when I'm about to give up, I spot a little black arrow. Following it, I soon find myself on a tiny lane barely big enough for my truck to fit. The lane turns into a two-rut path that leads to a parking lot. Thank god, there is an American car in it. I back my truck into a parking space and make my way down into the ravine where the barbecue is to be held. Our Partnership unit is a Reserve Unit, but when they throw a fresh open-air barbecue, they invite every retiree in the area. The Detachment First Sergeant beat me here only because he got lucky and had just four turn-arounds. The Germans have put up a tent so they can get plastered. They say they have room for us, but it is cold and I intend on sleeping in a bed. I order a coke. I make small talk with their unit Commander and a couple of his non-coms. My First Sergeant betrays me and tells them that I speak some Russian. Before I can beg off, they thrust some old fat guy in a gray Captain's uniform in front of me. He was on the Russian Front they tell me. What kind of fool do they take me for? Every old German fought on the Russian Front. None of them ever fought us, none of them were ever guards in the camps and none of them ever did anything bad. They all fought the Russians. Yeah, right! The old fat guy starts to speak. What in the hell is he saying? Sure, there are some Russian words, but I'm only getting 6 out of 20 and most of those are cusswords. I wonder if I'm that out of practice. Wait a minute…This isn't Russian…this is German…isn't it? I glance at the non-com standing next to us. He has no idea what the old fat guy just said, "Jesus," I think, "I'm in trouble now." It doesn't take me long to figure out what the Germans had in mind for me. They can't understand the old guy and he is a pain in the ass, but they would lose face if they didn't invite him, so once they found out that I speak some Russian, well, they dumped him on me. I tell him to slow down. He smiles, but his pace of speech remains unchanged. The old fat guy tells me he is originally from Magdeburg. He shows me paperwork that says he was drafted in 1940. He tells me he was at Stalingrad. He shows me a list of camps he was in when he was a prisoner. He points to his medals: the Iron Cross and the others, well, I have no idea. Except for one, which he skims by, the medal for fighting in the Partisan War. A cold chill runs up my back. He notices and shaking his head says, "volunteered by the SS." The non-com told me he was in the Signal Corps, but he shows me his

insignia for Signal Intelligence. He nods his head. Without a word, he knows who I am.

The Germans have a little ceremony. They hand out some awards, before it's time for food and more beer. After we eat, the old fat guy looks up at the darkening sky and says, "I've got to go, I don't see too well in the dark anymore." I walk with him to his car, a silver Mercedes, almost new. Despite the heavy overcast, his eyes twinkle as he says goodbye and with that the Universe has come full circle, except for the Spice Girls, everything is normal again.

Geneva Johnston Hudson

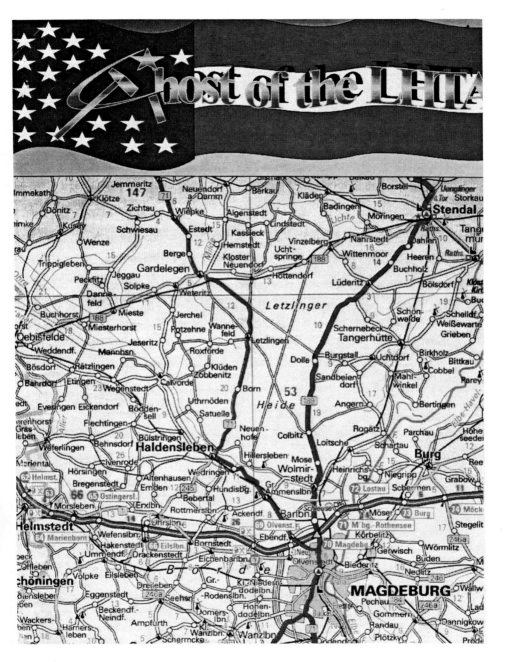

by
MSGT Barry K. Hudson

Geneva Johnston Hudson

INTRODUCTION

The reader can readily indentify the Letzinger Heide Training Area (LHTA) in Germany as an area where armies have practiced and perfected the art and science of war for centuries. It is a bit more difficult to discover exactly who the ghosts are. I have prepared this introduction to share with you my insights, but having talked to others who have read this journal, the ghosts are a literary conceit of vast interpretations.

To Barry the LHTA ghosts were real. They were the voices he heard daily over the radio waves as he conducted his survailance of military activity in the LHTA during the Cold War, a time when America was struggling for position as the most powerful nation in the world. Barry's ghosts were easily identifiable but in a larger sense the ghosts of LHTA are the echoes of those who have practiced war in the area for centuries.

The LHTA ghosts provided information of a possible conflict between the Soviet Forces of East Germany and NATO Forces in West Germany. Shortly after I receive a copy of this journal and had given it a quick read, I had an opportunity to talk to Barry about somethings that puzzled me. I asked him about the battle scenes he so vividly described, "Was that a World War II scene you were describing?" I asked.

"Mom! Read it again! They didn't have weaponry that advanced in WW II. This is a conflict that never happened, because MI was there.!"

After spending almost ten years as a signal inceptor atuned to the ghosts of the Heide, Barry had a burning desire to explore this haunt. His carefully laid plans and enthusiasm for this quest are glowingly outlined in his journal. The journey can be likened to a Lewis and Clark diary report on the flora, fauna, terrain, and human occupancy of the region. You will enjoy the beauty of the Germany landscape, the rivers and terrain while feeling a sadness for the scars of war that linger some fifty years later. Compare family life with that which you know, and discover the suspiciousness toward strangers, especially Americans, that lies close to the surface in the minds of Germany families. You will get a first hand glimpse of the economic divisiveness of East/West Germany reunification.

Be thankful for American highway engineering after reading about "getting there" following a Germany road map and the Autobahn system. What is an American traffic jam compared to an Autobahn stau? Although Barry spent ten years of his youth in Germany he was always the American critic.

Never one to do anything happenstance, you will understand his choices of CD's for this his "victory lap," are chosen to add color to the adventure, while the artists are companions and the lyrics conversation.

The seemingly endless sentence appears in a discussion of the American's susceptibility to an addictive high of anticipation. He traces the joy of anticipation from a childhood visit to the newly built Astrodome in Houston, Texas back to a rising expectation created by the Santa Maria. "Would I dare break up the thought of that sentence with some unimportant mark of punctuation?" The challenge is yours.

Consider this jewel of wisdom. "The Heide and its history are viewed as a fabric, the threads woven into a tapestry melding time together capable of being examined as individual eras or blended as a whole." And this bit of humor, "Someone must say it, so it might as well be me; the German road grid is Hitler's revenge against any American who has ever had to drive on it." And this, "Free is not an adjective to modify parking in Germany." Then this commentary on river crossing, "There are a lot of ways to get to the other side of a river; some folks go it alone, taking the struggle with the currents as part of the rite of passage. Others create governments, collect taxes, buy forms of concrete and bridge the flowing water so all might cross."

Barry encountered a enigma that if widespread would beg to put the lie to those who have stanchly believed that Christians were persecuted by the godless Communist East German rule. He uses a bit of sarcasm to sum up his observation, leaving the idea unresolved.

The future of the Heide will surely cause you to speculate upon what the final decision will be. Can a century old battleground be turned into a park where children play? Whatever the outcome it is probably true that it will not be accomplished without an invasion of the American pocketbook.

Finding all entrances to the Heide closed to him. Barry comes to the end of his journey without having removed the sword from the stone. We feel the mixed emotions in his closing allogory.

The *Ghosts of LHTA* is a three or four time read. The technological language is difficult but hopefully your first read will leave you wondering and unsure, but hungry. A second or third read and the technological language seems to be filtered out and you join the soldier in his quest.

Who are the ghosts? Surely they are the Russian Radio waves that Barry heard during the Cold War. Later they became the echoes of warfare across the scarred landscape of Germany. Are they the haunting memory of a soldier whose duty was to identify the enemy in such a way that the commander could see the "Battlefield?"

"It isn't til its' over that you're finally sure he's using ghosts as a literary conceit for unassimilated and unfinished human history." Pat Barber.

A long time ago, before we knew that light travels both as a particle as well as a wave, it was believed that an all-prevading, infinitely elastic, massless medium filled the universe. This medium was "The Ether." Since it was known that sound and other types of waves needed to have something physical to push through, it was believed that emanating waves of the electromagnetic spectrum pushed through this ether. Einstein and others changed all that by discovering that the electronmagnetic spectrum is both

Ghosts radio operators at work in the LHTA

particle and wave. It is a good thing, too. Otherwise, we wouldn't have those electric eye door openers at grocery stores. Think of all the man-hours saved by not having to clean up broken eggs because another customer failed in his struggle with the door. Not to mention the hours of counseling and cost of psychotherapeutic drugs saved by not having to suffer the embarrassment of having your accident announced over the intercom, "Johnny, another clean up at the door!" Nevertheless, the idea of the ether continues to be a part of our speech. Both English and Russian have phrases such as "out of the ether" to describe unusual or non-corpereal events. Since the term ether is also used to characterize the regions of the heavens beyond the Earth, ideas and people that are either bazaar or heavenly can be thought of as coming from "out there." Perhaps it is because radio still carries a certain magical quality about it that Russians still use the term in relation to the emanation and propagation of radio waves. I suppose you could call an ethereal emanation a Russian radio wave, but most folks commonly call them ghosts.

Letzlinger is a small town about 40 or so crow-flight kilometers northwest of Magdeburg, Germany. It would be just another no-account village on the low-lying North German plains if it had not lent its name to the vast forest region just a kilometer or so to its east known as the Letzlinger Heide. Bounded by Stendal to the north, Magdeburg to the south, the Elbe River on the east and its namesake Letzlingen on the west, the Heide's gentle hills are carpeted by thick groves of oak and beech and wide clearings filled with tall grass and wildflowers of blue, purple, orange, and yellow. Its dominate feature, Stenneckenberg (only 113.6 meters high) gives a high quality view of the terrain that gracefully slopes in the direction of the Elbe. Yet, the Letzlinger Heide is neither a peaceful nor a serene place. For at least a hundred years and probably longer, the Heide has been a training area where armies have practiced and perfected the art and science of war. Its woods have been splintered by shrapnel from impacting artillery rounds, its grasses and wildflowers have been crushed by infantry boots and tank treads. Lying at the heart of the Heide two gigantic concrete strips, constructed by Hitler's war machine to train and later launch pilots against the Allies, form a massive cross that runs the length and breadth of the zone. The ghosts would later call the longer north/south strip (approximately 40kms) the "Betonka."

Ghost Infantry on the attack through the Heide

It is only with the greatest difficulty that we can remember —the Ghosts. The Cold War, once so deafening, is now but a whisper of memory. At the height of their power they had twenty divisions inside of what was then called the German Democratic Republic. These divisions were divided fairly equally among 5 Armies that made up Group of Soviet Forces Germany (GSFG) 20 Guards Tank Army and 1st Tank Army occupied the eastern portion of East Germany with their headquarters at Bernau and Dresden respectfully. 2nd Guards Army faced Hamburg, though its headquarters was farther east in Neustrelitz.

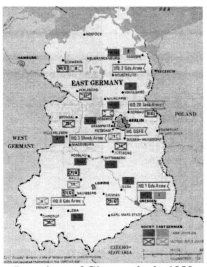

Locations of Ghost units in 1980

8th Guards aimed its menacing guns at the Fulda Gap. It was headquartered in Erfurt. The center of the line on the border between East and West Germany

was held by 3rd Shock Army (3SA). 3rd Shock was headquartered in Magdeburg. Basically the plan was for 2nd Guards and 3SA supported by 20 Guards to sweep the British Forces of the Rhine and West German elements from the North German plain and move into Belgium and the Netherlands hindering seaborne US and British reinforcement. 8th Guards with 1st Guards hot on its heels would blast through the US Army's 5th Corps defending the Fulda Gap and move through Frankfurt towards France. Soviet and Czech forces moving from Czechoslovakia would take Nuremberg pinning down the US 7th Corps in southern West Germany. Supporting units from the rest of the Warsaw Pact nations along with elements from the Western Military Districts in the USSR would mop up. If all went according to what was on paper, the ghosts, given a non-nuclear environment, would have been sipping wine in Bordeaux in less that a week of Sundays.

While each of the Armies had large training facilities in their local area, they each would come in turn to play in the Letzlinger Heide Training Area (LHTA). Not only did its size allow for the placing of an entire division on line, it also afforded the ghosts the opportunity to practice forced river crossings. Training in river crossing operations was important to the ghosts as the rate of their advance was dependent on the quick crossing of the numerous rivers flowing through Western Europe. The training units would form on the eastern side of the Elbe in the Altengrabow Training Area, move northwest through the small city of Burg (30kms NE of Magdeburg), ford the river near the western shore villages of Rogatz and Kehnert, stream westward through wide spots in the road like Malhwinkel, Tangerhuette, Uchtdorf to Dolle and Colbitz, where, after a brief pause to reform their lines, they continue forward to seize the Stenneckenberg, the Betonka and onward to the villages of Born, Gardelegen and, of course, Letzlingen. After which victory over the Imperialist would be declared and the Motherland's security once again preserved. When not used for maneuver training, the LHTA provided the ghosts a place to live fire artillery and small tactical missiles. In the LHTA, tankers learned driving skills on closed courses and fired on targets on various ranges. Infantrymen could fire their individual and crew-served weapons as well as practice with armored personnel carriers like the BTR-60 and BTR-70 and Infantry Fighting Vehicles like the BMP. Everyday, 24/7, for over 40 years, the Heide heard the voices of the ghosts roar. And for the better part of 10 of those 40 plus years, I heard them too.

The dawn of July 3, 1999 broke placid and calm over Wiesbaden. A soft yellow sun hung suspended in a blue-gray sky. It's rays, sparkling in the heavy water drops that still cling to the grass from the night's rain shower, made the ground a shimmering sea of silver and green. The thick air told you it was going to be a hot day — maybe 30C (TC x 9/5 + 32 = TF... do the math... it'll be good for you), maybe even 34C. That's real hot when you are used to temps in the teens. The leaves and limbs of the oak and beech trees held fast in anticipation of

a soothing breeze that was long in coming. And so too has this day been long in coming. One hundred and thirty six years ago on a hot July 3rd morning in Pennsylvania, George Pickett looked across a wide field at a clump of trees where a thin blue line stood defending the concept of freedom. Since that time, millions of visitors have come to see the ghosts that live in the heart of fields surrounding that little no-account Pennsylvania town. This day I am finally going to see my own Gettysburg. I am going where my ghosts charged beneath thundering guns. I am going to see if my ghosts still live in the heart of the Heide.

To say I am excited would be an understatement of the worst kind. As early as the 1st, I filled up the truck with Super plus and even added some octane booster. My red chevy pickup truck is back from its brush with death at the hands of an idiot that didn't understand the delicacies of three on the column shifting and allowed it to overheat seizing up the theromostat, bursting the radiator overflow tank and melting the vacuum lines.

My truck at the ready in Wiesbaden

Running semi-smooth with its new vacuum lines now feeding life-giving air to its two-barrel carburetor, my 350 short-block engine begs for a hard run up the autobahn. My thermos full of German coffee, CD's and camera in the carry position, I have but two stops to make before I can hit the highway. I must run by work to ensure my responsibilities are covered and hit the new 24 hour Shoppette to pick up road snacks. T minus 20 minutes and counting. I feel like screaming with joy.

Nine o'clock, two and a half hours behind schedule and still the Shoppette run to make, I still feel like screaming, but now, without the joy. Finally, I decide I've had enough; this is supposed to be a holiday and the new guys will just have to handle the momentous scheduling problems of video teleconferencing to find out just where that stupid train bringing our lone lost truck back from somewhere down southeast has gotten off to, all on their own. The new Shoppette is still shiny and new. It is the closest thing to true American convenience I've seen in Germany. I can get gas, liquor, a thirstbuster Coke (only 99 cents) and a microwave burrito all at the same time. If there were shotgun shells, big cups of coffee and nasty hot dogs, I'd swear I was in Texas.

To get to the Heide, I first must run up A66 (A is for Autobahn, B is for a good 2 lane "highway"), to Frankfurt, there I'll switch to A5 to start the Kassel run, just south of Kassel I'll catch the A7 north in the direction of Hannover, about 40 or so K's short of Hannover I'll grab the A39 shortcut through Braunschweig where I'll hit the A2 east toward Helmstedt, Magdeburg and

Berlin. Easy! About four and a half hours, max. Candy bars and chips, a couple of Diet Cokes and my trusty map in the seat next to me with Dylan's *"Changing of the Guard"* pounding on the speaker, at last, I'm ready for the road.

It is still cool enough to drive with only the floor vent and sliding rear window open. The Autobahn through Frankfurt is nearly "empty" about like I-35 through Waco at rush hour — busy but passable. Of course, I'm behind a Polish truck when the sign for the A5 Ausfahrt (exit) comes up, so I missed it. Normally, this would be a major problem, for often the next Autobahn exit is 30kms up the road, but since I'm in town the next Ausfahrt is only a short distance and in a matter of minutes I'm whizzing up the A5. By the time Dylan ends his <u>Street Legal</u> set by asking, *"Where Are You Tonight?"* I'm passing Elvis's army hometown of Friedburg. As the traffic thins out (I-35 through Norman at noon during the week), I am without cares and only have one concern — gas. German gas is just under four bucks a gallon. Since the difference in price is mostly taxes, our government cut a deal with the Herm Government, Esso (Exxon to you) and BP (British Petroleum) to let our soldiers, sailors and airmen use gas coupons bought at semi-reasonable prices. Right now, they are running around $1.60 a gallon. Still outrageously high, I know. You can use the coupons at any Esso anywhere and at any BP on the autobahn only. Trouble is that the Germans don't put up a gas station at every exit like we do in the States. Instead they are set up similar to the way Americans have them on toll roads — pull off and pull on stops with a restaurant spaced about every 60kms along the way with brand names switching at every stop. When you don't need gas, all the Esso stations and BP stations are on your side of the road; however, when you do, they are either non-existent or on the other side of the autobahn where you can't get to them. Worse yet, there are no billboards so you can't tell what kind of station it is until you get right up to the exit, thus half of the time you zoom right on by the Esso before you even realize what it was you just passed.

You might think that the lack of exit gas stations and billboards might add to the pastoral beauty of the countryside. And you would be semi-right. While it is true that German school kids still hang out on overpasses waving

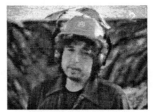

to passing trucks which they wouldn't be able to do if the traffic was increased by the placement of gas stations at the exits… and yes, my truck and I get lots of laughs, waves and pointing from the kids. The view of many of the picturesque little villages

Graffiti cleaner in Stendal

73

hugging the edges of lucious green valley walls are obscured by opaque noise-reduction barriers erected to protect the delicate sensibilities of the residents below. As time goes by, the barriers are being covered by the scars of gangsta-style graffiti. So are the bus stops, bridge abutments and many of the outer walls of the buildings in the cities and towns. This is a new thing. In the 80s, you would see the occasional hammer and sickle, anachist circle A or a Hans liebe Suzi, but in general, Germans respected the natural aesthetic value of their architecture and "spray art" was kept to a minimum. Americana spreads both the good and the bad. While most German gas stations now resemble 7/11's, minus the coffee bars, hot dogs, thirstbusters and Dr. Pepper, they bring one of the most important facets of American Culture — convenience. The downside is that many German kids think art comes from black and red spray cans that spurt out despair and decay to the heavy bass beat of purported Street Poets who call women (and everyone else for that matter), everything but a child of god. It gets worse, though, more and more, you see a uniquely German symbol painted next to the gangst-style tags… a Swastika. Time passes and some people just get tired while others just tend to forget.

I'm zipping along the A7 just past the university town of Goettingen and it is

Field Station Augsburg along with sister sites Wobeck (top) and Berlin (bottom) were important ethereal research facilities during the cold war.

time for a little Sheryl Crow. You can't live in the distant past forever, sometimes you have to try new things, even when they are between mediocre and real good, which is where this particular CD is located. The earth is beginning to flatten out and there is a big sky above. To the west, I can see the tall clouds of a front line; but, there are no thunderheads and they are still 6 to 8 hours away. About 40kms east is a mountain called Wurmberg. It is a no-account mountain today. But, once upon a time, Wurmberg played a vital role in the development of World

History. For you see, on its crest there was a tower and from that tower you could conduct ethereal research. Emanations captured by the tower were beamed by a series of microwave antenna to an ethereal research facility outside the Bavarian City of Augsburg. The research facility was located on an old Nazi airfield known as Gablingen. From 1981 to 1984, I performed research at that facility. From the Wurmberg tower, I could monitor ghost activity from Neuruppin to Gera and just about all points west of that line. On good days, I could catch them coming out of Potsdam or

Karl Marx Stadt (now Chemnitz, again). I concentrated my research on the ghosts royal family — the King (missiles and artillery), Queen (infantry), and Knight (armor) of battle. Frequently my research was hectic, frequently my hours were filled with empty static, but with each change in frequency there was always mystery and possibility. The best mysteries with the most possibilities always came from the LHTA.

Augsburg wasn't the only US facility in Germany conducting ethereal research. Back down the road, outside of Kassel is the little town of Eschwege. Atop this pleasant Fulda River Valley town sits Mt. Meissner. Both German and American antenna searched for apparitional activity taking place near Eisenach, Ohrdruf and Gotha and provided early warning for the US 5th Corps. Not far from Braunschweig, for which I am now heading on A39, lies the village of Wobeck. One of the original US sites, Wobeck focuses on the Heide and specters around Magdeburg. Farther to the south, near the Czech border, Schneeburg provided the vigil for the US 7th Corps. All along the border at dozens of sites, the British and Germans scoured the ether for emanations.

Geneva Johnston Hudson

H-1 helicopter positioned beside the enormous array of Field Station Augsburg at Gablingen, Germany. At one point, four battalions of soldiers had manned the site The field station was discontinued in 1993 **(Photographic History of Military Intelligence).**

I visited my son, MSG Barry Kent Hudson, in Augsburg in 1981. He took me for a tour around the area where he worked, pointing out massive antenna sites here and there, but always saying that is not my antenna. I'm wondering, as I look at this picture "Is this his antenna?")

Geneva Hudson

The heavens were not ignored. The skies were full of birds that both looked and listened. Of course, Augsburg's archrival was Berlin. Surrounded by ghosts, Berlin had the advantage of position, but the residents of Gablingen always claimed they had the greater desire, superior skill and better beer. In the 60's and 70's ethereal investigators would make a career of moving from Berlin, to Monterey, California, to Wobeck, to San Angelo, Texas and then on to Augsburg. The 80's saw the spread of the investigators down to the technical level. What these researchers lost in linguistic and technical skills during their banishment to posts like Ft. Riley, Kansas, Ft. Polk, Louisiana, and Ft. Hood, Texas, they made up for in tenacity and leadership skills. This Corps of Hunters was tight and proud, full of character and legends both famous and infamous, all serving gloriously wrapped in their anonymity. The laurels for their victory were never awarded; the lessons of their struggle are now passed over, exchanged for some new technology. As my truck pulls out from the Einfahrt (entrance) onto the A2, I am lost in memories both melancholy and warm. It's time for new music.

The accordion is about as traditionally German as a musical instrument can get. Every fest oomph band from Ulm to Bremen has at least one, that and a tuba. I think the guy that plays at the Hofbrau Haus in Munich can really rock. He pales, however, when compared to Sammy Naquin. Sammy plays accordion for the Cajun Playboys and he is just beginning to swing into his magical riffs on *"Lafayette Breakdown"* when the road sign tells me I have 16kms to Helmstedt with 60 something more before I'll reach Magdeburg. Sammy and a clear road up ahead are just the ticket to shake a bad funk. Couple that with some heat from a high sun, some mild humidity, flat lands, a little breeze and a pickup truck that can two step and you have the makings of a grand glorious 4th of July eve — all

76

The Satu outside of Helmstedt

that's missing are pop-bottle rockets and beer and I figure they'll at least have the latter in the Heide. And at my current cruising speed of 75mph, I should reach my goal of the heart of the Heide by 13...uh-oh...red lights...two cars...now ten...it might be...it could be...it is...A Damn Stau.

A Stau is about as traditionally German as a traffic jam can get. Every Autobahn from the A1 heading into Hamburg to the A6 heading for the Austrian border has at least one — a day. I think the ones on the A3 heading either out from or into Frankfurt are the worst. No one knows what causes them, because you never get to the head of it. The Stau just ends as traffic mysteriously starts moving about as suddenly as it stopped. This is going to be a bad one, for Hans, who looks 55 and is wearing my khaki-colored shorts, has just stepped out of his car and with his shrugging shoulders has given me the universal language sign for "I have no clue what is going on." He grabs a couple of huge pears out of the cooler in his trunk and tosses them to his wife before getting back in the sitter's seat. As the Playboys start to shake out *"Jet Ais Au Bal,"* the 20-something Dutch girl with the silver thing stuck in her lower lip area impatiently croons her neck to see if there might be an inch of space through which she might pass the Swedish truck and the zillion other cars locked in front of her. Rejected and dejected, she pounds out her frustration on the numbers on her cell phone.

Motorcycles stream like salmon between the parked cars and along the sides of the road. One time, just one time, I wish I had a bat or a long pole when they did that...I'd catch one right in the throat...that would teach at least one of them to stay in line and be miserable like the rest of us. Hans up ahead pays them no mind; he's seen this all before, so with a toss of my non-existent long hair, I let the hate go and return to rocking out to *"Madelaine."*

Same Stau rear view

We move ahead 10 meters during *"Petite Ou La Grosse,"* and another 10 meters during *"Colinda."* The slow lane, however, is making a little better time. This gives me a new dancing partner; much more pleasant than the little Dutch girl. It's a weird looking European red van thing with kids in the back. They pass me only to stall 10 meters ahead.

Ten minutes tick away bringing me my turn now and I pass them up by 10 meters. We do this dance for the better part of the next half hour and each time we pass, the kids wave. They've probably never seen a red Chevy before and I've certainly never seen whatever it is they have.

The Border today

It's flat out hot now, every part of me is sweating, even my fat feels like it is melting through my belly. About the time I put on Freddy Fender, my lane gets to make a big jump to the middle of nowhere leaving the kids far behind on the edge. Engines turn off, doors open, people get out and stretch, some curse the heat, some the situation, some just go over to the shoulder and pee, then as if on cue, hope is restored and everyone rushes back to their cars to race up 5 or 10 meters only to do it all over again. By the time Freddy is dead and buried in his sleeve and Brooks & Dunn are about half way through their <u>Greatest Hits</u>, someone finally says Abracadabra, opening the gates; we are moving again. Funny thing, though, there are no gates ahead—only road construction. The lanes are a little thin, but they are comfortable enough for my truck. There used to be gates ahead. Just east of Helmstedt was the border crossing. When the East German border guards were being picky, traffic would pile up in both directions for tens of kilometers. That's all gone now, and it makes me wonder if people just stop here out of habit.

When I was a kid, my parents took me to Houston to see a ball game at the nearly new Astrodome. I don't remember much about the ball game, but I do remember the game we played on our way into the city. The goal was to be the first to see the Dome. The flame of anticipation burned higher and higher the closer we came to the city. And then it was there, gleaming white, almost hovering over the empty parking lot. Just as the Dome can be seen as a symbol of American willingness to trade tradition, even to the point of negative return, for perceived "new and improved" convenience, it is our demand for and susceptibility to the addictive high of anticipation derived from the desire for change or the discovery of the uncharted, that simultaneously carries the contradictory fatal flaws of self-destruction and the righteous virtues of progress and fuels the core of American attitudes and forms the crests of the waves of rising expectation first created by the wake of the Santa Maria and that yet spreads throughout the world. More than simple hope, anticipation in the form of rising expectations, like an unquenchable thirst, implies, no, compels action and it is evidence of that action that I am searching for as I cross the old border area.

A half score and six years ago during the winter solstice, I came down this part of the road. I had flag orders in my pocket and a yellow VW Rabbit full of family. We were heading for Berlin, just because. The rest stop I just passed may have been the US Checkpoint Alpha. Who knows? At Checkpoint Alpha, they logged you in, dissected your paperwork, gave you a briefing, searched your trunk, gave you a stack of cards to flash at East German cops, ordered you to stay on the Autobahn, warned you that you would receive a ticket if you got to the other side too fast and assured you they would come looking for you if you were slow in arriving. Then they sent you on your way to see the ghosts. The ghosts I saw was a baby. His face had yet to feel a razor. His boots were unpolished. His eyes were of cold cobalt blue. Saying only, "Please," he gave me back my

papers and pointed me to a door draped in dark shadow. As we pulled away from the ghost, across a short fence, beneath the heavy gaze of the watchtowers, stalled European cars rolled back in both directions for tens of kilometers, desperately awaited the final wave of an East German border guard.

Some people say that time is just a measure of distance through space. Some people say that time is a river by which the flow of events throughout the universe move in one continuous unidirectional stream. Some people say that time is not linear at all with past, present and future all existing simultaneously, as if in some giant pool and we only experience the linear aspects of time because we only interact with it at one point as opposed to being diffused throughout the pool. Time, in the area that stretches from the former border between east and west to at least the Elbe River and at a minimun from Magdeburg to Stendal, is a fabric, the threads of which are woven into a tapestry, where past, present and future each can be examined individually and yet, when viewed from a distance, are blended to make the whole.

Huge gas stations, more like American truck stops, have taken possession of the land that once was the crossing sites. Enormous pads of broken concrete, through which new grass and hundreds of old style streetlights grow, surround the stations. Empty guard towers with broken kieglights stare down on new overpasses that stand dormant awaiting connection to a part of the Autobahn yet unpaved.

Guardrails protect nearby road construction crews and hem narrow traffic lanes that run over terrain where fences topped with razor wire once held sway. Farther on, just past the border zone, no-account villages of broken red brick and dark gray-brown walls

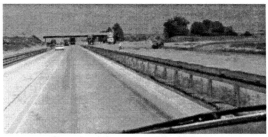

Construction near Magdeburg

that haven't seen paint in 50 years stand in dark contrast to glistening new factories. An exit or two later an old East German Traubie sputters off in the direction of a sign announcing a colossal shopping center that looks almost mall like. The sign flashes "buy" with all the joy and power of a Sousa march, but without the subtlety of countermelody. Yellow construction cranes dot a landscape quilted from patches, some monochrome others full color. Their superstructures break up a horizon that modulates its amplitude with arrhythmic frequency. I slide the truck into the slow land to ease my pace in hopes of collecting all of the sensory input, but the spectrum is too busy and the queues of my memory bank are overwritten. As I reach the approaches of Magdeburg, I get my first glimpse of the low southern hills of the Heide. To reach the prize, I

must take the B189. This means I must drop the general scan of my perimeter and turn instead to the higher priority of locating a small blue and white sign that will point me toward Stendal.

Someone must say it, so it might as well be me; The German road grid is Hitler's Revenge against any American that has ever had to drive on it. Not only are the vast majority of drivers who drive it insane, but also the entire road network makes absolutely zero sense. On the US Interstate, odd numbered highways go north and south, even numbers run east and west; but on the autobahn, highway numbers have no meaning. They have kilometer markings on the side of the road, but they do not relate to the Ausfahrts, which are numbered sequentially, if they are numbered at all. And while we are on the subject of highway interchanges, it is my opinion that German Einfahrts and Ausfahrts are the personal design of Satan's Angel of Death. The best way to enter the Autobahn is by screaming "Get out of my damn way you bastard Herm," loud as you can as you try to catch as much acceleration as you can on the dwarfish enterance ramp, while you pray that the idiot behind you doesn't cut you off by stealing the small hole in traffic you are gunning towards. Exiting is an entirely different adventure. The deceleration lane taking you from the Autobahn is generally short, ending in a sharp insufficiently banked curve that if you overshoot you will find yourself smashing into a recently replaced concrete pillar. If you are lucky enough to make it past the initial curve, more likely than not, the exit ramp becomes an endurance trial featuring a long winding road that seems to curve around until you have hit at least six points on the compass and ends up at a traffic light that is destined to be red. Dizzy and bewildered, you sit through the next two green lights, your ears blasted by the horns of the impatient, as you try to figure out just which little Dorf on the yellow direction arrow is the first wide spot you must encounter on the road to your destination. If you are fortunate enough to survive your drive and find your intended objective, you won't find a place to park. "Free" is not an adjective to modify parking in German. If you are going to park in a city, you can forget the idea of trying to squeeze into a parallel parking spot (metered or pay box) on the street and just move on into a pay lot or garage. Even small cars have to make two or three trips in reverse to fit in the narrow parking spaces of the pay lots. So it is with

utter amazement that I find my truck cruising up the high-banked curve of the cloverleaf Ausfahrt to merge with ease onto the new concrete of B189 Nord. Across the overpass on the left sits a new multi-store shopping center. Its unregulated parking lot is wide and

inviting. America now marks the gates to the Heide.

A couple of kilometers past the shopping center, the road changes from concrete to new blacktop and loses its straight ways and resumes the curved nature customary to a German secondary road. The Rolling Stones want to *"Paint it Black"* as the truck takes the left swerve in the road bringing me into a no-account village on the outskirts of Wolmirstedt. They don't need to paint it black; it already is—except what's not dirty brown. The streets are empty, even the bars are closed. The only traffic is heading the other way. You might say this place has been forgotten, except for the fact that the sidewalks and streets were swept clean that morning. A moment later I'm in downtown Wolmirstedt. On the left, there are a couple of row apartment buildings. Coats of fresh yellow overlay the scars of neglect. A few people brave the sun to stroll in the small park a block or so from the apartments. A group of teenage girls, coming in colors, cross at the stop light at the next corner. Their conversation and arms remain animated despite being forced to spread wide to dodge a middle-aged man walking his black dog. The man is too rushed by the need to finish his melting ice cream cone to notice me, but his dog takes a moment to stare and give me a bark. The new sign tells me where the girls are going...McDonald's is just up the block.

I have decided to go down to see where the ghosts crossed the Elbe and then follow their trail moving back into the Heide from the east. Just past the Ford dealership, I make a right turn onto a narrow macadam road toward Loitsche and Rogatz. Between Loitsche and Wolmirstedt there is a large power distribution station that

The Rögatz Ferry

appears to be something out of a bad Sci-fi flick from the fifties. Huge transformers and monstrous brown ceramic resitors hanging on rusted steel towers look like an army of robots marching across an alien prairie. At the edge of Loitsche there is a fork in the road. I need to stay on the priority road to go to Rogatz, but the macadam looks the same in both directions and the sign is of no use. Naturally, I choose poorly and have to cross the Mittelland canal before I can turn around. I pull into a thin farm lane to do my turn about. It isn't until I've backed out onto the road that I realize that the thin lane is a hardened tank trail. This trail and two others run northeast toward the Elbe and the village of Schartau, which is located on the east bank. Another pair of trails on the west side of the canal head toward a grove of trees on the north side of Loitsche. A few seconds later I'm back on the right road passing through grasslands and

wheat fields. I'm getting hungry, but Rogatz is closed, so I pour a little coffee into my cup and follow the signs down to the ferry boat crossing.

There are a lot of ways to get to the other side of a river. Some folks go it alone, taking the struggle with the currents as part of the rite of passage. Others create governments, collect taxes to buy forms of concrete and bridge the flowing water so that all might cross over. In Rogatz, they have taken a middle way. The ferry between Rogatz and Schartau holds about four cars. It runs on a schedule, so you must

An ethereal view from the east side of the Elbe. Ghost Recon elements check out the site.

wait your turn. It's engines turn slow and steady across the surface, so you have to have patience. And when you get to the other side, you will realize you still haven't gotten anywhere at all. The Elbe at Rogatz isn't wide; Washington could easily chuck a silver dollar across it. The ferry has just arrived as I stop the truck in the nearby empty parking area so I can take some pictures.

A pair of young mothers have brought their tow-head blond children to enjoy the lazy afternoon on the docks, but the ferry isn't very exciting and the kids have become a little restless. Two tribesmen of Attila, their leather vests dusty and hard from dried sweat, roar their chopped Harleys off the boat. The kids point and laugh at them as they cross the docks. The mothers gather their babies to their laps to hold tight. The tribesmen kick up a little dust as they stop their machines at the entrance to the parking area. As one begins to adjust his clutch linkage, the other fiddles with the handkerchief he has tied over his long, dark, greasy hair. His replica Iron Cross medalion glints in the sunlight. Downstream, beneath some shade trees, a concrete path leads ghost tanks down to the river to catch their ferries. I hop back in the truck, run up the engine, pass by the bikers now basking in the sun, and head down the road to where Malhwinkel awaits.

———

Nervous infantrymen huddled tight in the dark compartments of their BMP's and whispered about everything but the river ahead. Overhead, Scuds, ranged deep into enemy territory bringing command control points and communication centers an early breakfast of 300 kilotons of nuclear unhappiness. They cut through the black early morning sky trailed by the same dim orange glow that came from the infantrymen's cigarettes. The clatter of the tank engines responding to the order to start was muffled by the din of the fast moving Fencers screaming at treetop level toward the guns that must be muted on the other side of the river. Long milignant columns spread out from their assembly areas and

moved with stealth to their attack positions. Ahead, MIG's spat darts at radar blips covering the ground attack of jets playing their last trump before racing back to refuel and rearm on the well camouflaged airstrips in the rear.

The King of Battle belching fire and sizzling steel from hundreds of throats, 122mm, 152mm, and 203mm in diameter, dispersed across the narrow front, while short-range SS-21's rained chemical death on the enemy's reinforcements slowly moving forward from their second position. Beneath a blanket of smoke, reconnaissance elements secured the near bank and marked the routes to the river fords. Hip helicopters brimming with troops escorted by Hind gunships settled in cool LZ's on the far side of the river. The infantrymen from the Hips rushed to seize and control the crossing sites, while the flying tank Hinds suppressed futile enemy resistance with anti-tank Spiral missiles and withering fire from their 12.7 machine guns. As the artillery rolled its barrage to deeper targets, the initial Motorized Rifle Regiment began the next phase of the assault. The sharp boat-like bows of its BMP's dipped the scoops of their tracks into the water, propelling them forward. T-64 tanks, with tall snorkels for deep fording, submerged into the river to provide the infantry in the BMP's the armor punch needed for the break through on the far side. Still dripping from their swin, the tanks and BMP's quickly assembled in tight formations and pressed forward toward their first objective, a north/south road some 8 kilometers west. With speed and vigor, the regiment scattered or destroyed localized enemy strong points before stopping in a wood line just beyond the road to take up a hasty defense for the counterattack that was sure to come. With the foothold established engineers brought up GSP ferries and PMP pontoon bridges to rush the remainder of the division across and further exploit the penetration. With the river now at their backs, only victory, highlighted by the morning sun breaking through the surrounding smoky haze, lay ahead. Some of it happened. Some of it was just practice.

––––

The narrow north/south road between Malhwinkel and Rogatz tracks over wrinkled ground that slopes softly toward the Elbe, about 8kms to the east. It darts across wide green meadows girdled on the perimeters by tree belts that, on occasion, close tight to the road for a hundred meters or so before giving space to a new field. The remnant of an old tank trail runs along side the east side of the road most of the way. Other tank trails coming up from the river split the trees and bisect the road at irregular intervals. Short decrepit towers dot the clearings. They could be deer stands, but I can't imagine Bambi coming this close to the road just so some local can blast him. They are too short to be of any service to the Forest Meister. Yet they really don't fit into my imagination of what ghost observation towers would resemble. I give up trying to figure out what they are,

as a more pressing matter vexes me. I pull the truck off the empty road onto one
of the tank trails so that I might commune a little closer with nature. A soft
breeze carries the scent of a recent trash fire. Over the treetops, a small, solitary
hawk makes lazy circles in the sky, but I'm the only one around to watch. I hop
back in the truck and press forward. Just outside Malhwinkel, the locals have
gathered around a swimming pond. A couple of thirty-year-olds give me a hard
stare as I pass. The black top changes to cobblestone as I enter the red brick
village. Everyone must be back at the pond, because there is not a soul on the
street. At the fork in the road, I take a right turn in the direction of Kehnert.

Kehnert is so small, it isn't even on the map, which is probably why I got
such a strange look from the farmer, whose house I passed on the way out of
Bertingen, the last town on the map. Other than the fact that part of the river
bottom near Kehnert is concrete, no one would have ever heard of it. The new
blacktop on the road is deceiving, for the road is so rough that old tapes, coffee
cups and just about everything in the cab of the truck that isn't seat belted down
is flying, even at 30mph. A short distance before you reach Kehnert, there stands
a set of old white barracks partially hidden from the road by a wood line. They
are nearly overgrown with tall weeds and vines. Every window you can see is
broken. No marker remains to say who lived there. The road changed back to
cobblestone as I enter Kehnert, though this is no break on the truck's suspension.
The cramped curved entrance to the village is banked on the right side by a short
wall, which displays the evidence of a few scrapes with wide vehicles. The
roadside houses of Kehnert sit on a long bluff that overlooks the river a short
distance away. Not far pass the wall, the road makes a Y. The top road takes
you the length of town; I take the lower line, which promises to lead *"Down to
the Waterline."* Swinging with Dire Straits around the curve below the houses, I
see an old couple taking it easy beneath a shade tree. Their wide eyes betray the
consternation they are feeling at my unexpected arrival. Another 50 or so meters,
almost hidden by trees, is another swimming pond filled with screaming kids
watched by mindful adults setting safely ashore. Another 50 or so meters and my
visit to this part of the Elbe is stopped dead in its course. The cobblestones have
grown to the size of boulders. You might take a tank or maybe a BTR across
this, but there is no way I'm going to go forward in the truck. I climb to the top
of a small mound for a peek at the river. Tall grass and wildflowers carpet the
uneven ground and screen the riverbanks. Across the river, a radio tower rises
above a grove of trees and stretches out to touch the hazy heavens. I wave
goodbye to the old folks on my way out of town. They don't wave back, but, I
suppose, they'll have something to talk about at the dinner table for at least a
week.

Back in Bertingen again, I switch roads in hopes that the way to Cobbel
might be smoother for Phil Collins to tell me about my *"True Colors"* than the
well-beaten path back to Malhwinkel. It isn't and the CD seems to be skipping

even more than before. It is obvious that the new state government of Saxony-Anhalt forgot an inclusion for graters and rollers in their road repair budget. Cobbel is planning a fest at the end of the month, or at least that is what the banner that hangs over the road says. But the people must not be very excited about it, for the streets of Cobbel are deserted. With nowhere and no reason to stop, I move on to Birkoltz, just outside of Cobbel, a pair of Berliners have stopped to take pictures of an old windmill. Three tourists in one day and Cobbel didn't make one sale; does that not speak well for the introduction of a Capitalist mindset among the villagers along this part of the Elbe. Although her stucco and red brick show signs of recent repair, Birkoltz is just as sleepy as her sisters. It is a good thing that it is hard to get lost in a one-road town, for there isn't anyone around to ask for directions. The big town of Tangerhutte is next on the line of march. Past Birkoltz, the road evens out in time for Phil to tell me there is something *"In the Air Tonight."* This close to the river, I just hope it isn't mosquitoes.

At least the storekeepers of Tangerhutte have an excuse for being closed;

**No! It isn't so ugly that it is cute!
This Traubie is in good condition**

eveyone in town is at the soccer game. The truck sidesteps and drives by some trunkgaters (it is impossible to be a tailgater without a tailgate) eating sandwiches between the cars parked on the side of the road. The teams are just about to retake the field after a scoreless first half. Ahead, a man and a woman have had just about all the excitement they can stand as they pull their Traubie in front of me, without signaling, to head home. I suppose, signal lights were optional on Traubies. The Traubant is a classic piece of East German automobile engineering. Small enough to fit in the bed of my truck, it is powered by one sick hamster. Deluxe models have two. It is said that a Deluxe Traubie can go from zero to thirty in just over a minute. Owners of Traubants that have had their floorboards rusted out consider themselves fortunate, since they can use the Fred Flintstone method of starting their cars on cold mornings, or any morning for that matter. Not counting the couple who pulled out in front of me, there were six Traubies, four Fords, three Audis and two Opels parked along the road in front of the ball field. Only two of this number were built after my truck's 1986 year of birth. Of course with the Traubies, how could one really tell?

Being near the river, this should be good farmland, yet very little of it is plowed. Between Kehnert and Tangerhutte, I have seen maybe a half a dozen wheat fields, a couple of acres of corn and only one herd of cows. Heading out of Tangerhutte on the way to Uchtdorf, there appears to be a relic of collective

poultry farm. I suppose the rusted tin structures could have held pigs. Two 7-meter grain towers look down over a complex made up of 20 tin pens and a couple of support buildings. Since this place is out of service, it makes me wonder just how the people of this area make a living. The primary question asked by most West Germans. Dispite the jubilation that poured out into the streets when the wall came down ten years ago, the luster of the new marriage between East and West has not worn well. Alienation between the industrious West Germans and their poorer Eastern cousins is growing by leaps and bounds. Prior to reunification, the West German economy was the envy of every European nation. Exports of pharmaceuticals, machinery, electronics and automobiles brought the West Germans the expectation of a high living standard. West Germans pointed with pride to their nationwide free health care system, quality schools, impressive old age pensions and a variety of other social programs. Few West Germans complained about their high taxes (in comparison with the U.S.), for they could reach out and touch the results of those taxes in improvements to road and rail transportation, higher water quality and scientific advancements and new recreational facilities. Those feelings changed the morning after sledgehammers brought down the wall.

Outside of the industrial centers around Berlin, Leipzig and Dresden, much of pre-WWII eastern Germany was agricultural. The vast destruction of these industrial areas during the war left the new Communist masters of the GDR little infrastructure with which to create a Workers Paradise. Fears in Moscow of a resurgent Germany, brought the GDR little assistance in economic development from its new friends in the east. While her western cousins enjoyed the fruits of America's Marshall Plan, the leadership of the GDR mismanaged her industrial output and wasted what little fortune she had on adventurism, weapons, sports "medicine" and barbed wire. As a result, when reunification came, the Eastern states were at a minimum 40 years behind the technologically advanced West. Outside of terrorist organizations, drug cartels, survivalists and American High School students (all of whom could be supplied much more easily and cheaply by China and the former Soviet Republics), there was little demand for AK-47's, so the East German factories shut down, throwing thousands into the unemployment lines. West Germans now saw their tax dollars flow eastward to fund the reconstruction of the neglected and dilapidated East. The new road, the new water treatment plant, the new hospital filled with new doctors would have to wait until the East was rebuilt. The worldwide recession of the late eighties and early nineties hit

the German economy hard. The proud and hard-working West Germans now saw the safety net they had so long labored for extended to cover people who would not or could not work.

Ask a cab driver in Frankfurt what he thinks of East Germans and the nicest word he will use is lazy. He will point to the road construction around the International Airport and tell you it is at least seven, if not, ten years behind its completion schedule. He will make sure you feel every pothole in the road that has not been repaired. He will tell you he now has to wait months to see a dentist to get his teeth cleaned. He will tell you that he may now have to wait until he has been buried for six months before the podiatrist will be able to see him about the bunions on his feet. And he will tell you that the reason for all of these problems is because all of his tax money goes to pay for some fat woman in Leipzig to lay around her state apartment, drink beer, eat bon-bons and have babies. West Germans don't just resent East Germans, what many of them feel borders on hate. A hundred years ago, most people considered a German as being someone from Berlin. Prussians or East Germans were Germans, everybody else was just a Bavarian, a Hessian or some poor putz from the Black Forest. Today, West Germans, like Americans, consider themselves to be Germans first and then a resident of their state. This is not to say that they don't have state pride, Bavarians brag about the beauties of Bayern as much as any Texan brags about that godawful place south of the Red River. It is to say that West Germans have developed a positive form of national identity. East Germans, on the other hand, see themselves as East Germans and then Germans. Hiding behind personal walls, they tend to fear contact with foreigners West Germans included. Nevertheless, opinion polls continue to show that an overwhelming majority of West Germans tend to have a positive outlook on the future as a whole and a positive outlook on the development of a true feeling of togetherness between the two sections of the nation. Seeing themselves as second-class citizens, it is the East Germans that are pessimistic about both issues. Maybe they just listen to too many Frankfurt cabbies.

The whole purpose of this trip is to reach the Betonka in the heart of the Heide. I double-check my map in the driveway of a used car dealership just before I pull out of Uchtdorf into the long shadows of late afternoon. The map swears that all I have to do is stay on this road through Burgstall to Dolle, make a right on B189 Nord, go up

toward Stendal a little bit, where I can turn left and head out into the Heide and onto the Betonka, 6 to 8kms maximum off the main highway. Outside of Burgstall, there is a small white castle on the right side of the road. This castle is a Schloss (big house) as opposed to a Burg (the fortress thing with towers that most people thing of when they think of a castle). Before I can read the sign that says who it belonged to, my attention is captured by a more interesting structure. On the left side a little farther along, a dirty-white tower with broken windows sits atop a small blockhouse. A pair of omni-directional antennas are perched on opposite corners of the railing that runs around the tower's crown. Wrapped aroung the tower is a circular course of steep grade hills, tight turns, soft sand, ditches and rippled bumps that ghosts tankers used for drivers training. Suddenly, a kid on a dirt bike flies high off one of the steep hills. Beneath his flight, I can see more towers in the distance, marking the locations of firing ranges for both small arms, as well as tanks. On the right side, flattened dirt pads held ranks of big guns that once lofted their shells with an arc that would lift them over the tree line ahead, carry them high over Dolle and B189 and bring them down safely somewhere 6 to 8kms west of the last point of civilization.

The old red brick Gasthaus on the corner of B189 and the Burgstall road advertises a lunch special. Although it is almost dinnertime, there are no smells coming from the place to indicate that someone inside is preparing for the evening crowd. I pull into the vacant lot across the street to recheck the map one more time. On the other side of the highway, Mary's sad eyes looks down on the scroll of the honored dead of Dolle from the Franco-Prussian war. It's a short list — ten names out of a town of what — two hundred? According to the map, within a kilometer north, there should be a road much like the one I just came down from Burgstall that goes across the Heide to B71 and Gardelegen. Moving slowly with eyes on alert, I ease out onto B189 searching for a concrete strip that will take me to my final objective. The concrete that runs in front of Mary turns into dirt and disappears into a farmer's barn. You would think she could have at least warned me that this path was fruitless. On the outskirts of town, a metal barrier bars entry to a two-wheel dirt path that cuts through a wide clearing before dissolving into an oak grove. Frustrated, I continue to march. Broken tank trails running along both sides hold back the thick forest canopy from overhanging the highway. Shards of golden sunshine pierce through the dense leaves and burst over the ground in staccato pulses that leave all that surrounds trapped in a conflict of ever changing patterns of color and darkness. A kilometer passes, now two with no left turns to be had, only an endless

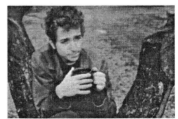

Even on a hot day the residents of Colbitz like their coffee

88

series of tank trails blocked by ditches and huge mounds of earth topped with signs saying entrance is forbidden. A kilometer later, I give up concluding that things are just not going to work out going in this direction. I whip the truck into a cut off entrance to a tank trail, give the map a quick check, turn around and head back through Dolle to start plan two. Motionless, Mary offers me no clues to where the trail to the center of the spirit world begins. Her silence says I'm still on my own.

Colbitz lies about 9kms south of Dolle on B189. Although my faith in my map has been shattered, it promises that the road that crosses the Heide between Colbitz and Letzingen is still open. Outside of Dolle, the accompanying tank trails disappear and the forest gives way to wide fields on both sides of the road. To the right (west), there is a large hill covered in oak and birch trees. As it is the only hill in the area it must be Stenneckenberg, but I have no way of knowing for sure as there are no right turns to take me to that part of the promised land. Entering Colbitz, Neil Young tries to warn me that *"Everybody Knows this is Nowhere,"* but I pay him no heed, for ahead there is a stop light with some blacktop heading west. As I wait for the light to change, the waitress for the Gasthaus attached to the Colbitz brewery opens the shutters, gives a drink to the flowers in the box below the window and brushes the dust from her hands before vanishing into the darkness of the room. While I could use a beer and a schnitzel about now, mission comes first and the last thing I need is to be stuck out in the middle of the Heide in the middle of the night. The high quality blacktop dies about a block from the light. To the right a thin strip of concrete leads to some kind of small industrial concern, to the left huge cobblestones head toward downtown Colbitz. This being the GDR, I choose the hard road of the left, as the right holds only smooth promises but no real prospects. "Good god! What were these people thinking!" I scream over the noise from the beating the truck is taking from Colbitz's main street. Whatever these things are, they are not cobblestones. They range from 20 to 30 centimeters in diameter and put an entirely new meaning to the terms *Shake, Rattle* and *Roll.* Within two blocks at only 5mph, my glove box has shaken open two times, half the trash from under the seat has vibrated out onto the floorboard and my CD player has experienced space flight. I have no time to sight see downtown Colbitz; I am too busy trying to catch all of my possessions before they fly out the window. Ahead the street forks again and I stick to the left side as it seems to be heading in a more westwardly direction. On my left, the town cultural and children's recreation center is closed. Big surprise! Who can think of culture or recreation after being beaten half to death by the street?

A block or two farther, a sign says I am bound for the Colbitz waterworks. Soon after the street mountains are replaced by a half dirt half broken concrete thoroughfare. Unfortunately it dead-ends at the waterworks. Despondent and forlorn, I turn about and head back to the Avenue of Torture. Slam! I put on the

brakes hard to avoid making Bambi a hood ornament. This event makes me re-think my entire theory about the short towers in the fields around Malhwinkel. In Germany, street signs are optional. However, if you find one that has the name of a town on it, generally this means that if you stay on that street you will eventually end up in that town. Sure enough, the name of the street at the second fork in the road is Letzlingerstrasse. I would say things are looking up except for the fact that the "cobblestones" on this street make the mountains back on Main Street look like foothills. Around the corner, Conrad has stopped his Traubie in the middle of the street to talk to Grandma. Her white hair tells me that she is old enough to know better than to take her walker out on terrain like this. About half a kilometer farther, the street ends. I circle around in the dirt, stop the truck and get out to investigate. There really isn't much to see, except a grove of acacia and chestnut trees in the distance. Distressed and incensed, I get back in the truck and begin the implementation of plan three. As I pass by her house, I am glad to see that good sense has gotten hold of Grandma and she has returned inside. The truck sighs with relief as its tires caress the pavement of B189. We are southbound again.

Plan three means that I am abandoning B189 for B71 on the western side of the Heide. This will give me a minimum three more possible points of entry, the Betonka, itself, at Hillersleben, the Letzlingen side of the Letzlingen/Colbitz road and the western side of the cut across that Mary denied me back in Dolle. As I leave Colbitz, a large bird coasts on a sweet breeze high over the Heide. It dips in and out of the western sun hiding its identity as it keeps a close watch on what is going on below. Sixty kilometers and twelve years into the western sun, my bird floated above the gentle North German Plains around slow banks in bounded circles like ripples on still water. Her aluminum and steel belonged to the 11th Armored Cavalry Regiment, her direction to the pilots, her heart to the crew chiefs, but her electricity and magic belonged to my crewmate and me. It was the two weeks following the ides of July 1987. My unit had managed to escape the doldrums, dust and mud of NATO training center in Grafenwohr for a chance at some live ethereal research across the fence from the Heide. Based on a German airfield near Celle, we worked in concert with our ground-base affiliates set up in the vicinity of the Volkswagen and Porsche test tracks adjacent to Ehra-Lessien. Looping us around a nuclear power plant, our flight plan profiled the border towers and barbed wire scar below; however, the Heide was kept from view, hidden beneath a hazy horizon. Our time over the plains was uneventful, yet the rewards of memory are not only received for

overcoming the obstacles of life, sometimes they are gained for simply managing the mundane.

The right turn at Mose leads only to a few apartment buildings. Waiting for the traffic at the intersection of Mose lane and B189, I watch a young couple across the road leave their Traubie parked on the road to inspect their dreams at a new Daimler-Chrysler dealership. The man lusts after the muscle of a SUV, while the woman runs her fingers over the more practical lines of the Dodge mini-van. The truck flees from the infectious spores of new car fever spreading from the realm of their fantasies and soon is *"Cruisin"* with Smokey Robinson past McDonald's and on through the narrow twisting back streets of Wolmirstedt in search of an open road to Hillersleben.

Located on the southern boundary of the LHTA, Hillersleben provided the testing grounds for a pair of 80cm guns (about 32 inches) constructed by Germany's first family of death, the Krupps, for Hitler's war machine. The Dora (named for the engineer's wife) and the Gustav hurled mini-van size shells into the Heide from specially constructed railroad platforms. Later, the Gustav would shell Soviet positions around Sevastopol. The Dora may have made an appearance near Stalingrad, but her combat record is shrouded in mystery and controversy. Nevertheless, if she fired at all, she had little effect on the outcome of that battle. In 1945 with Soviet and US forces closing in on their hiding spots, the Nazis destroyed the big guns before they could fall into the "wrong hands." Time passed and the ghosts found Hillersleben's ideal location much to their liking. The village became the home station for the 47th Guards Tank Division of the 3rd Shock Army.

Rounding a curve, I can see the blood red twin spires of Hillersleben's church tower thrusting through the town's lust green forest crown. As I enter the town, a set of broken yellow barracks of the 47th Guards stands across a little field on the right hand side of the road. The gates are locked tight and there is no path that leads around the barracks on which I might gain an entrance to the Betonka. The right hand turns in Hillersleben only lead to dead ends or in circles. The church, Luthern I believe, is almost in the center of town. Without a mark on it to say otherwise, it looks to have been in continuous operation since at least the 1600's. This is strange, considering there was an entire division of godless communists dedicated to the utter destruction of anything religious living within 500 meters of this place of worship. It was long past dusk, as I recall, as we past Magdeburg on that December trip to Berlin so many years ago. Although the decrepit state of the GDR's infrastructure was shocking, the most surprising event of that trip was the exhibition of Christmas lights. It seemed as if every village and farmhouse along the road was trimmed in dim white lights. (Germans tend to use understated white lights for their personal outdoor Christmas displays, as opposed to the lavish colored pageantry we are familiar with in the U.S.) Perhaps all of those East German villagers were only expressing

their celebration of the coming of the New Year. Perhaps the villagers of Hillersleben were herded out at gun point from their lighted homes on the evening before December 25 and forced to go to the old church, now a community center, to be told by their communist masters the details of the village's upcoming economic plan. Perhaps much of what we have been told about the state of religion under communism has been baseless propaganda. Perhaps the truth lies somewhere in between.

On the western edge of town, the broken barracks of the 47th Guards come back into view. On closer inspection, it appears that they may run the length of town, but it is hard to tell from my vantage point. Like the white barracks outside of Kehnert, they are heavily overgrown with grass and weeds and everything that can be smashed is smashed, windows...doors...everything. The remains of a long building that might have been a mess hall has had its roof set aflame. Beyond it, there are newer buildings, but their condition is no better. At the far end of the new barracks there is a road that promises to lead behind the post to the Betonka. Of course, my passage is checked by an iron gate. Restricted again, I turn the truck around and head on down to B71, where with fading hopes, I turn north to begin the search for the heart of the Heide anew.

With little struggle, the truck sweeps over the rolling hills of the southwestern Heide. New asphalt and fresh lines make B71 a fairly good highway. Wide by German standards, its thin shoulders give way quickly to short chumps of grass that crawl up the sides of the runoff ditches before joining the tall weeds that make up the forest floor. Oak trees dominate the mixed woodland. On occasion the tree line breaks and you can see into wide grasslands topped with multicolored wildflowers, the range of which is interrupted only by stands of oaks grouped in three's and fives's. The sign hanging company of the Bundeswehr has been busy, for on the right (east) black and white metal posters at regularly spaced intervals ward off would be visitors with messages of dire consequences should they choose to proceed into the forbidden land. The signs multiply around the exits of the tank trails, which have been blocked by mounds of earth or red and white metal gates. Blinking, I miss most of Born. Just beyond that village, the landscape begins to level, while the flora and the

mad-made objects continue their established pattern the rest of the way to Letzlingen.

It is hard to tell if the faded poster on the outskirts of Letzlingen was originally purple or blue. Put up sometime in 1997 (the rest of the date has been eaten away by time), it calls for a rally sponsored by some group called the Friendship Cooperative to take place in Haldensleben to protest the continued militarization of the Heide. The Cooperative wants the Heide to be preserved as a wandering area, where Germans can stroll about and harmonize with nature. There was to have been a folk band, food and a march to an unreadable location under banners that would call for peace and for the Bundeswehr and NATO to stay out of the Heide. According to the German press, the future of the Heide is a matter of some controversy. This is true, as well, of other former military training areas both east and west. While groups of activists wish to see the Heide demilitarized, the German Defense Ministry wants to use the Heide as a laser-tag style maneuver training area, where tanks and other fighting vehicles can have at it without the dangers forged from live rounds. Shortly after the ghosts were exorcised from Germany, the Bundeswehr, not wanting to see good land go to waste, took control over the area with the intention of implementing this plan. Unfortunately, they ran into a little problem. It seems that the Heide possesses a deadly obstacle — unexploded munitions. DUH! For the best part of this century, tons upon tons of rounds have rained down on this region and it should come as no surprise to anyone that many of them just flat didn't explode as planned. In 1995, the Bundeswehr hauled out demolition experts armed with high tech metal detectors, spent about $20 million and by 1997 they had managed to clear a little over two square miles of the 88 square mile area. The German government now estimates that it will take around a billion dollars and 35 years before the Heide will be safe enough for the German Army to be able to play army in it. Couple these figures with the expected costs for the clean up of dozens of other training areas as well as unexploded Allied bombs from World War II that still linger just below the surface of many of Germany's major population centers and it is easy to forecast that the German government's budget will be hamstrung by these efforts for some time to come. It is unclear whether anti-military groups such as the Friendship Cooperative wish to see the German government spend a billion dollars over the next 35 years so civilians can amble down the Betonka and enjoy the wildflowers.

Geneva Johnston Hudson

After seeing Colbitz, I had come to the heartfelt conclusion that our Earth was out of unemployed rocks. I was in error. The rocks of Letzlingen's Colbitzerstrasse, the opposite end of the infamous Promenade of Pain, heave forth from the ground with amplified anger and disdain for moving things. The truck cowers at the first corner, and I perceiving little chance of advancement and that in this case prudence vice patience might truly be the better part of valor, bend to the will of its shock absorbers and return to B71. Mary Chapin Carpenter may be "*Keeping the Faith,*" but I'm not anymore. There comes a day in your life that you realize that you are just not going to get there, wherever that "there" might be. You finally accept working on the probables instead of wishing for the possibles; it just means that you can find satisfaction in something less than the "perfect life." It just means that you stop being a child. As important as a birthday, the Day of Acceptance of life as it comes is the first day mortality is comprehended, but it doesn't mean you have to "veg out" until the guys with the carts and machines stand over you and scream "clear;" it doesn't mean you accept the "fates" without a fight, and it doesn't mean you don't take a right turn on a road that heads toward a town that isn't on the map and just might lead to the heart of the Heide.

A single row of trees line the left side of the narrow backtop street. Brown and gray houses divided into two and four apartments crowd the right side. Traubies, Ladas and a couple of old Audis, all on life support, litter the street. Gingerly, avoiding the fatal plague of time, the truck picks its way through the hospice. A wall of trees marks the eastern boundary of Letzlingen. The road narrows yet again as it tunnels beneath the thick limbs laden with full leaves. Beyond lies a clearing in gold and black. A child of six runs through tall grass with arms that seem to stick out of his chest and legs that pump more up and down than forward. He aims his stick at something invisible in the trees, before stopping to give me the kind of hard look that lies squarely on the line between fear and curiosity. His grayish stucco village is across the lane on the left. Five buildings, topped with dark brown slate, fall in at odd angles behind a long house that fronts the street. Just past the long house, trees shield a rundown campground. The road changes to a dirt path as it passes the empty camp stands and vacant picnic tables. At the end of the campground the road forks in three

directions. The two forks to the right die at barriers within meters of where they break off the main trail. The truck and I move forward into the the tightening timber. A few meters more stands red and white metal barrier number 24. Its gate is wide open and inviting. The black and white sign next to it cries danger ahead. It speaks of duty and responsibility. It demands a soldier's obedience to orders. I take a long look at the sign and a longer one at the landscape before I put the truck back into gear. A secret breeze rustles the leaves and dances through the grass by the white birch tree on the left.

An Old Cold Warrior

It turns out that the kid was a born informant. As I drive back through his gray settlement I see him busting me out to Grandma. He points his stick at me, while she shoots down the old cold warrior with bitter arrows fired from her evil blue eyes. I smile and wave like a good American, but she mumbles some sort of curse that indicates her feelings for "foreigners" are lodged deep between hatred and fear. The truck gets her message before I do and moves out smartly. In the front yard of the apartment back in Letzlingen, some kids are bouncing a soccer ball off an Audi and raising their arms like they just scored the winning goal of the World Cup. When I reach B71, the truck informs me that it is in need of gas. While it is not an emergency, I know the chances are slim that I will find an Esso station anywhere close. In fact, the only Esso I remember seeing is way back on the Autobahn at the former border crossing and it, of course, would now be on the wrong side of the road. The certainty of the purchase of German gas looms like the approaching thunderstorms in the distant western skies. An unusual problem arises out of being in the middle of nowhere Germany; village gas stations are generally closed by 1800 on weekends. This being the case, the odds are even that I will find an open pump in either the direction toward Haldensleben and Autobahn2 or toward Gardelegen and down B188 to Wolfsburg. Choosing the latter, I turn right and head north on B71. As fortune would have it, a brand new convenience store is open on the outskirts of Letzlingen. I turn left into the drive. The truck eases into the extra wide spaces between the double row of pumps. Inside, the simple shelves are stocked with ample supplies of the essentials —candy, chips, bread, Coke Lite, and beer. The counter girl, with a thing in her nose and short violet hair, scarcely interrupts her chat with her friends to ring up my sale. I toss the extra Coke Lite in the seat, pop the top on the other one, hop in the truck, rev up the engine and head north to Gardelegen.

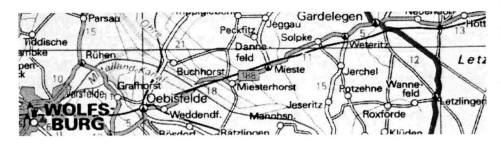

B71 does some kind of strange loop at its intersection with B188. This section is all new highway, so it is possible that the engineer was a recent graduate from Magdeburg University. Perhaps it was designed by the Art Department and I just don't understand its form over functionality. Some roadside businesses and an RV dealership are spaced between houses on the entrance to Gardelegen. Downtown has fresh paint and new fronts on most of the buildings. Unfortunately, they rebuilt the traffic circle. To make matters worse, they neglected to put up all the signs necessary for one to know which way to go. I guess only locals are expected in Gardelegen. After getting fouled up on some back street, I make it back to B188. The western sun is beginning to set in my eyes. Summer sunsets are abnormal this far north. For awhile, you are sure it is on the way down, then all of a sudden it seems to pop back up into the sky, before settling down to a lengthy twilight. B188 is a work in progress. The old parts are narrow and make curves in the middle of open fields for no apparent reason. Had the ghosts chosen this road to make their visit to the west, which they surely would have had to do, their armored columns would have been stacked up in open terrain for kilometers. The new parts are wider, but at nearly every crossroad or village I encounter, they force me to make senseless long loops that lead to stop signs before picking up the new road again. The villages along the road alternate between nearly repaired and falling apart. Each of them consider road signs a luxury, leaving me with heightened anxious feelings of being lost. Nevertheless, things are going semi-smooth until the detour sign rears it ugly head at the entrance to Oebisfelde. The detour takes me through the center of the village, where the Colbitz style cobblestones are being torn from the street to make way for new pavement. A man my age struggles to pedal his bike on the dirt path that fortells of a future main street. The old buildings zealously wait their turn at renewal. West of Oebisfelde, a short stretch of new road gives way to old, which then arches across an open field before disappearing into a long line of trees.

On the other sides of the trees, in a soft meadow of hostile design, she waits for me. Her featureless concrete fails to hide her gender. Her weathered surface

fails to hide her youth. Her expressionless face fails to hide the terror of her past. Her empty eyes fail to hide the loneliness of her present. Her armless figure reaches for understanding from a land where only calls of fortune seem to be returned. Bold and confident, she accepts the impending thunderstorms knowing that sometime she will find some place in this universe a shelter she can call home. At her feet, a short wall made from the essence of her own body provides security for her superstitions, suspicions, dreads and doubts. Below the wall, a brook of tears slowly carries away generations of sorrow, fear and hatred, and gives fresh life and new hope to the grasses healing scar extending from the northern to southern horizon. Shimmering twilight bends low to again conceal the secrets of the distant Heide. As the truck makes its way across the one lane bridge into the dying western sun, she concedes, at last, to share with me the ghosts of our collective memories. Silently, she assures me that, locked in her heart, our ghosts will forever remain riddles wrapped in mysteries inside of an enigma.

MSGT BARRY KENT HUDSON
July 3, 1999

Geneva Johnston Hudson

ABOUT THE AUTHOR

Geneva Johnston Hudson grew up in rural Oklahoma County. She attended public school at Putnam City, and is a graduate of Central State University in Edmond, Oklahoma. She is a retired public school teacher, having taught in the Edmond Public Schools for sixteen years. Currently she is a free-lance writer of educational materials.

Among her many accomplishments and honors are: Oklahoma Council for the Social Studies Teacher of the Year; Oklahoma University and Oklahoma Bar Association Exceptional Service Award for Law Focus Education; Edmond Mayor's Appreciation for Volunteer Community Service; Honorary Life Membership Kansas Parent Teachers Association; and National History Day Distinguished Service Award. She is listed in *Great Personalities of the South,* and *Who's Who of American Women.*

She is the author of: *Oklahoma: The World Around Us,* a fourth grade textbook published by Macmillan Publishing Company 1990; *Barefoot In An Oklahoma Sticker Patch,* published by Gem Publishing 1996 and distributed by 1stBooks Library 2001; and *Shaping Oklahoma: A Map Study,* published by Gem publishing, 1999.

0324